the KODAK Workshop Series

Color Printing Techniques

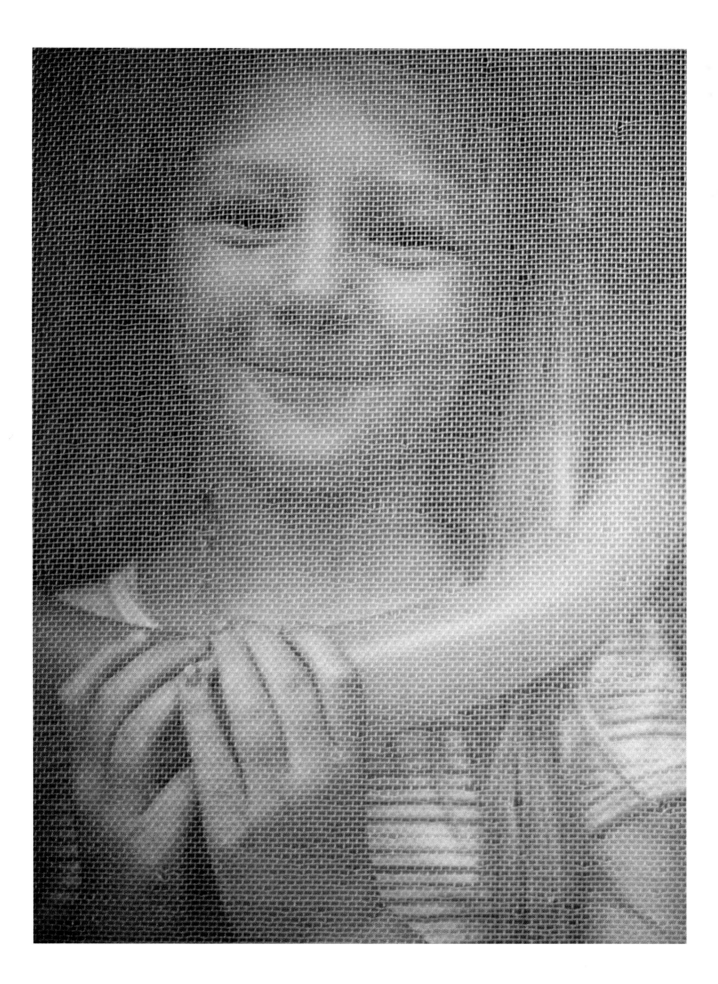

the KODAK Workshop Series

Color Printing Techniques

The KODAK WORKSHOP SERIES

Helping to expand your understanding of photography

Color Printing Techniques

Written for Kodak by Vernon Iuppa and John Smallwood

Editor, John Phelps

Picture research, William Paris

Book Design: Quarto Marketing Ltd.
212 Fifth Ave.
New York, New York 10010

Designed by Roger Pring

All photographs from the Eastman Kodak Company files except:
Tom Beelmann—cover, pages 20, 30-31, 75, 95
Steve Labuzetta—how-to and product photos
R. Hamilton Smith—page 2
Tony Boccoccio—pages 21 top, 37

© Eastman Kodak Company, 1981
Consumer/Professional & Finishing Markets Division
Eastman Kodak Company
Rochester, N.Y. 14650

Kodak Publication KW-16
Library of Congress Catalog Card No. 81-66743
ISBN 0-87985-275-5
CAT. No. 144 0841

11-81-GE New publication
Printed in the United States of America

Throughout this book Kodak products are recommended.
Similar products may be made by other companies.

Contents

INTRODUCTION

There are many ways of making color prints. They can be as simple as one solution using KODAK EKTAFLEX PCT Materials or as complex as dye transfer. This book begins with the simplest process and introduces you to the ones that are somewhat more complex.

Regardless of which process you choose, you will be starting out with either a color negative or a color transparency. The various alternative processes are represented here schematically beginning with a color film original and ending with a finished print.

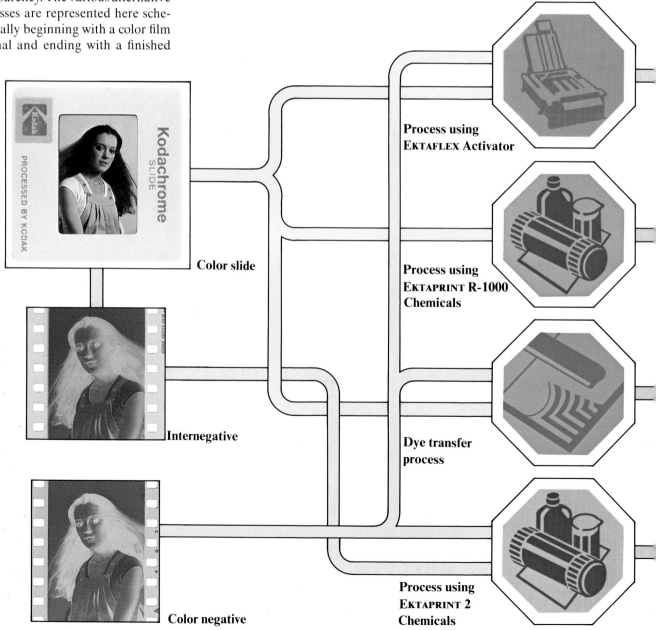

Color slide

Internegative

Color negative

Process using
EKTAFLEX Activator

Process using
EKTAPRINT R-1000
Chemicals

Dye transfer
process

Process using
EKTAPRINT 2
Chemicals

ALTERNATIVE APPROACHES TO COLOR PRINTING

Alternative	Used for prints from	Difficulty	Cost	Quality level
EKTAFLEX PCT Materials	negatives or slides	easiest *1 solution*	somewhat more expensive than EKTACOLOR or EKTACHROME Papers	excellent
EKTACOLOR Paper	negatives	somewhat more complex *3 solutions*	least expensive	excellent
EKTACHROME Paper	slides	even more complex *5 solutions*	slightly more expensive than EKTACOLOR Paper	very good
Dye transfer	negatives or slides	extremely sophisticated *numerous processes involved*	most expensive	the ultimate

ABOUT COLOR PRINTING

You might as well have the facts of the matter right up front. This book will be honest with you about making your own color prints.

Happily, though, the plain, honest truth is that making your own color prints is really very easy and enjoyable, *once you learn the basic procedures*. And that's what this book is all about.

Actually, the very *best* way to learn the basics of color printing would be to have someone show you how, step by step. But since you may not have such a person handy at the moment, you can use this book instead.

Just think of this book as a good friend who's going to spend a few hours helping you learn how to go it alone in the dark and mysterious world of color printing. A friend who's going to show you how it's done every step of the way.

When you finish, you'll find that color printing isn't so dark and mysterious after all. In fact, we think you'll agree that it's a rather enjoyable combination of artistry and alchemy, and a great way to round out your enjoyment of photography.

Before we plunge headlong into the business at hand, let's take a moment to answer some of those nagging questions that you've been wanting to ask.

Q. *Just what kind of book is this anyway?*

A. This is a basic, how-to, step-by-step book designed to help make your first color printing sessions as productive and easy as possible. In the universe of books on color printing, this book offers a simplified "cookbook" treatment of information, as opposed to other books on the subject which may be more detailed and all-inclusive in a "textbook" sense. So if you're looking for an advanced book on the theory of color, this is not it. Not that color theory isn't important. In fact, we think you should know something about it. But we'd like to suggest that you cover that topic *after* you've had the opportunity to make a few color prints. Then, chances are, the explanation of colors and their relationships will be a lot more meaningful to you.

Q. *Why should I even consider making my own color prints?*

A. The answer has a lot to do with control and satisfaction. You exercise a certain amount of creative control over an image when you photograph it—when you capture it on film. And that kind of control gives you satisfaction, the joy of photography. But when you can also exercise your own creative control and judgment over the creation of the final image, rather than letting another person or a machine do it for you, then you're experiencing one of the ultimate satisfactions of photography: total creative control over the image from start to finish.

Q. *What is the most difficult thing about making a really good color print?*

A. Without a doubt, it's finding the right combinations of filtration and exposure to get a good print. This is a trial and error process. Experienced printers can usually find the right combination after making 3 or 4 prints. Inexperienced printers often make quite a few prints before they get a feel for it. Fear not, however, because this book will help you to develop the experience you need.

Q. *Is this an expensive hobby?*

A. Everything is relative. The best way to think of it is in terms of the money you already have invested in photography. With that in mind, you'll find that equipping a darkroom for color printing (or even equipping a darkroom from scratch) will probably cost you less than your SLR outfit. And beyond that, once you get good at it, you'll probably be able to make top quality, custom color prints for less than what they would cost you elsewhere. Plus you get all the enjoyment out of doing it yourself!

Q. *Does color printing require exotic facilities and lots of fancy equipment?*

A. Not in our book. Refer to pages 14 and 15 and see if you don't agree.

Q. *How much time does it require?*

A. More your first time through, less as you get used to it. On average, though, a typical color printing session (10 prints) should take you about 2 or 3 hours, and that would include the time needed to set up your equipment, expose and process your prints, and put everything away. All in all, an enjoyable way to spend an evening.

Q. *How does making a really good color print differ from making a really good black-and-white print?*

A. It's easier to make color prints! In both cases, finding the right exposure is the same. You do it by making a test strip. Then, when printing color, you find the right filtration to balance the color in the print. When printing black and white, you find the right paper grade or filter to give you the best contrast. They are both a matter of experience. But when it comes to processing, that's where color gets a lot easier. Where black-and-white requires all sorts of chemicals, trays, and washes, KODAK EKTAFLEX PCT materials are processed in the EKTAFLEX printmaker in less than half a minute. And the printmaker just sits on the counter top. It doesn't even need a sink. If you know how to make black-and-white prints, color printing will be easy. If you've never done any printing before, color printing with EKTAFLEX materials is a good way to start.

Q. *Am I ready for color printing?*

A. If you are already familiar with making black-and-white prints, then making your first color print may be a bit easier. But it's not a requirement. Simply being of reasonably sound mind and body is all that's necessary. A sense of humor doesn't hurt either.

Color printing and processing

THE COLOR DARKROOM

To begin any kind of color printing, you must have a darkroom. It need not be anything very elaborate and can be no more than a lighttight closet, big enough to take an enlarger and some processing equipment.

If you intend to do a lot of printing, you may prefer a custom-built space, with room to mount and finish your prints. Kodak publication KW-14, *Building A Home Darkroom*, con-tains plans and detailed advice for converting small spaces or building a fully equipped darkroom. Whatever it may look like, a darkroom must include certain features:

1. It must be lighttight, even around doors and windows.
2. It should have good ventilation (do not block out all the air with the light).
3. It should be kept clean and dust free.

The illustration shows a darkroom equipped for color printing using KODAK EKTAFLEX PCT materials. For safety's sake, you should always keep the "dry" and the "wet" sides clearly separate. That is, position the electrical equipment (like the enlarger) apart from processing equipment (like the Printmaker) that uses chemicals.

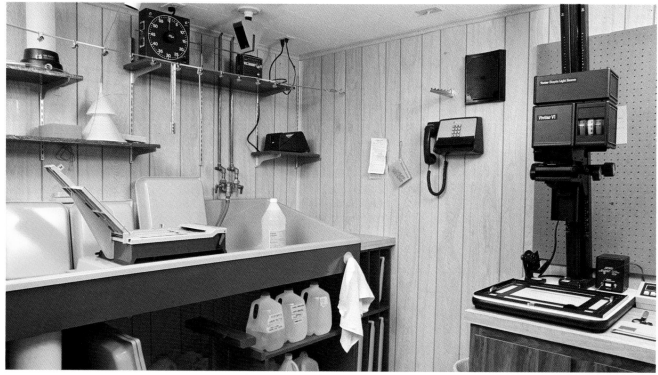

HOW AN ENLARGER WORKS

The components of an enlarger are really very simple: a light source, and beneath that, a holder for the negative or slide and a lens which projects and magnifies the image. In a color enlarger, the light source must be filtered to balance the color in the print. This may be done by three dichroic filters, positioned near the light source, which you can move in calibrated stages into or out of the light beam by means of a set of dials. Or the enlarger may include a filter drawer, above the negative, into which you put colored filters of different strengths to filter the enlarging light.

*There are three filtration controls on a color head (dichroic) enlarger, marked **Y** (yellow), **M** (magenta), and **C** (Cyan). As you adjust these controls the color of the light is controlled by movable glass filters. These controls are calibrated, usually in cc filter units.*

The exact design of negative carriers varies, but the principle is constant: they must hold the negative flat by its edges during enlargement, minimizing the buckling effect the lamp's heat has on the film.

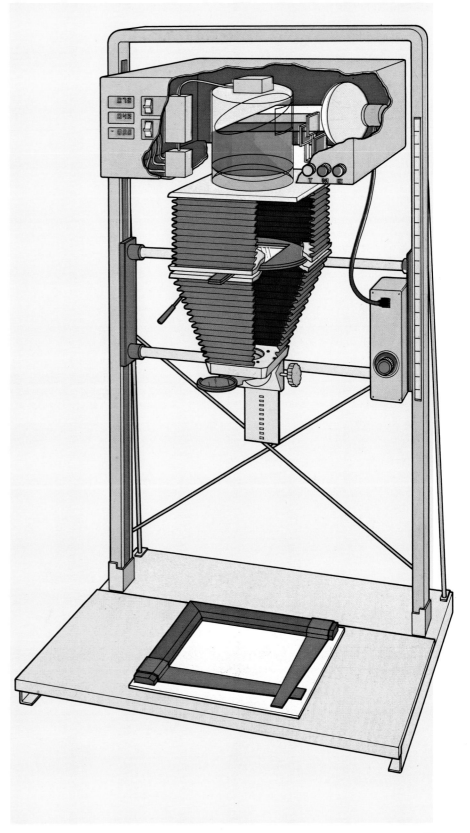

PRINTING EQUIPMENT

The enlarger is the most important piece of equipment on the "dry" side of your darkroom. To begin color printing, you can use the same enlarger that you've used for black and white along with a set of color printing filters. But if you don't already own an enlarger buy one with a color head. You'll want one eventually, anyway.

BASIC EQUIPMENT

These are the bare essentials. If you just want to try out color printing, you can work with the equipment shown. Any black-and-white enlarger that has a drawer for filters can be used. When buying filters, get a set made for color printing. The Kodak color printing filter set (Acetate) contains everything you'll need as long as 3 inch (75 mm) filters are large enough for your enlarger. Any old enlarging timer will work as will

any easel, brush, and similar equipment. If you already have a black-and-white darkroom setup then all you'll need is the set of filters. But the equipment shown is to a well equipped darkroom as a 110 pocket camera is to a 35 mm SLR.

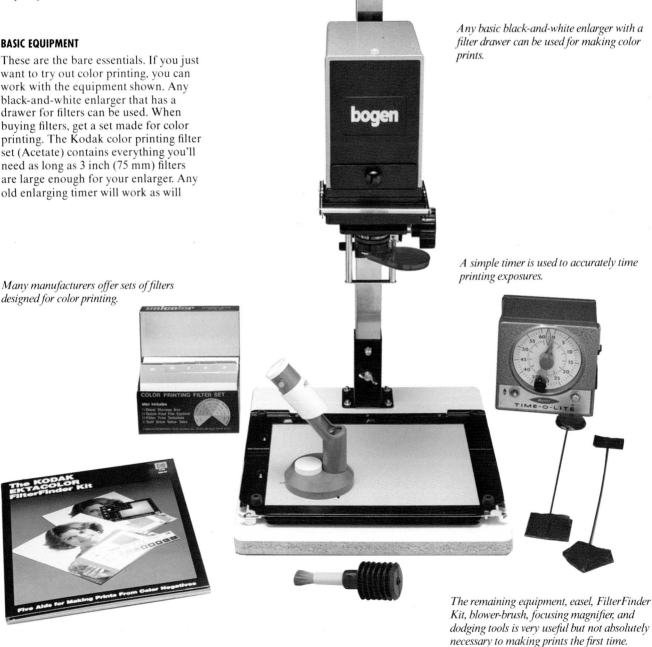

Any basic black-and-white enlarger with a filter drawer can be used for making color prints.

A simple timer is used to accurately time printing exposures.

Many manufacturers offer sets of filters designed for color printing.

The remaining equipment, easel, FilterFinder Kit, blower-brush, focusing magnifier, and dodging tools is very useful but not absolutely necessary to making prints the first time.

ADVANCED EQUIPMENT

Shown below is the sort of equipment you might find in a well equipped darkroom.

A well equipped darkroom is like a well equipped camera bag—it takes time to fill it with tools with which you are comfortable and you'll probably go through several generations of equipment before you find the things that feel just right.

A color head enlarger with a voltage stabilizer will give you the best light source for enlarging. And a top quality enlarging lens will give you the sharpest images. Buy either a grain focuser or a focusing magnifier so you can focus sharply.

A paper safe is a lighttight storage box for unexposed film or paper. EKTAFLEX PCT Film should not be stored in one of these indefinitely, however. Keep EKTAFLEX PCT Film in the original packaging whenever possible.

An analyzer can be a useful tool but only if you already know how to print well enough to program it properly. Analyzers aren't of much value to workers who are still learning basic skills.

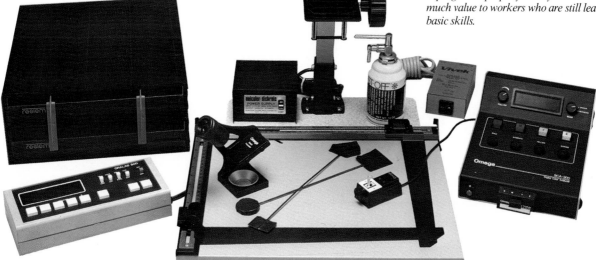

A digital timer is a useful accessory. You can use it to time both enlargements and processing.

PROCESSING EQUIPMENT

Even less equipment is needed for processing color prints than for exposing them. Using EKTAFLEX PCT materials, the KODAK EKTAFLEX Printmaker is the only piece of equipment you will need on the "wet" side. The Printmaker holds the EKTAFLEX PCT activator in which the exposed film is processed. Then a set of rollers laminates the paper and film, passing both out at the end of the machine. After a few minutes, paper and film can be peeled apart to reveal the positive image, which was transferred onto the paper by the photo color transfer (PCT) process.

At the exposure stage, printing negatives is somewhat different than printing slides but using EKTAFLEX materials, the processing steps are identical. Other methods of color printing are described beginning on pages 50 and 64. These are more complex, and negatives and slides follow very different processing procedures. They can be used when you want to make prints larger than 8" x 10" since EKTAFLEX materials aren't available in larger sizes.

To begin color printing, we strongly suggest you start by making prints from color negatives using EKTAFLEX materials.*

Very little equipment is needed for either exposure or processing; everything you need is described on page 14 and here. An enlarger and a Printmaker are essential and will probably be your biggest investments when starting color printing.

It is actually somewhat easier to make prints from slides but EKTAFLEX reversal film won't be available until some time in 1982, so unless you can wait until then, start with negatives.

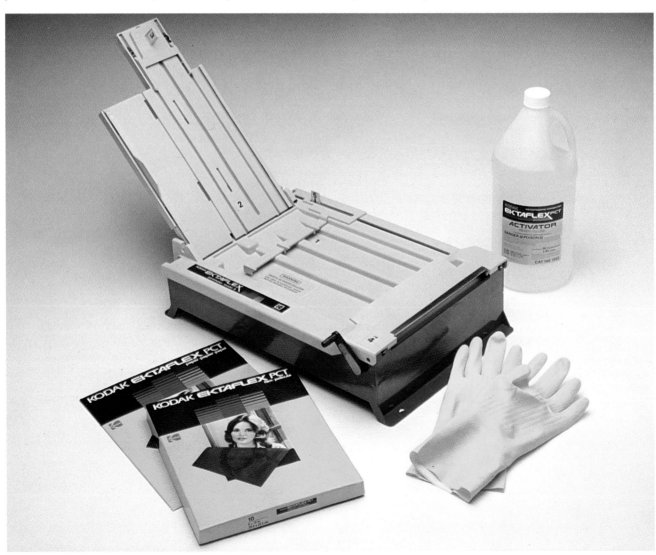

USING KODAK EKTAFLEX PCT MATERIALS

KODAK EKTAFLEX PCT materials have greatly simplified making color prints. In the past, color printing from negatives or slides required several processing chemicals which had to be kept fresh and within a very narrow temperature range. Now, all you need is EKTAFLEX PCT film (negative or reversal, depending on whether you are printing negatives or slides) EKTAFLEX PCT paper, which is used for both negatives and slides; EKTAFLEX PCT activator; and the EKTAFLEX Printmaker.

Gone is the need for all sorts of equipment like storage bottles, mixing containers, graduates or beakers, processing tubes and temperature controllers. You don't even need an expensive color processing thermometer. Any reasonably accurate thermometer will do. And processing is no longer a tedious series of steps that need to be timed exactly. Only the time the film is in the activator needs to be carefully monitored.

After that, the print can be peeled whenever it is convenient. (Within reasonable limits, see page 25.)

After being exposed, the EKTAFLEX PCT film is then fed into the Printmaker and the emulsion sides of the film and paper are laminated together and cranked out of the Printmaker through a set of rollers. After that, the lights may be turned on. Then only a few minutes later, the film and paper can be peeled apart and you'll have a completely processed color print. The emulsion will be a bit damp but all that needs to be done to dry it is to let it sit for a few minutes. It will quickly dry without any special care. The entire procedure is explained on pages 24 and 25.

Another nice feature of EKTAFLEX PCT materials is that the prints don't have to be completely dry to evaluate color balance. The color of the print does not change as it dries.

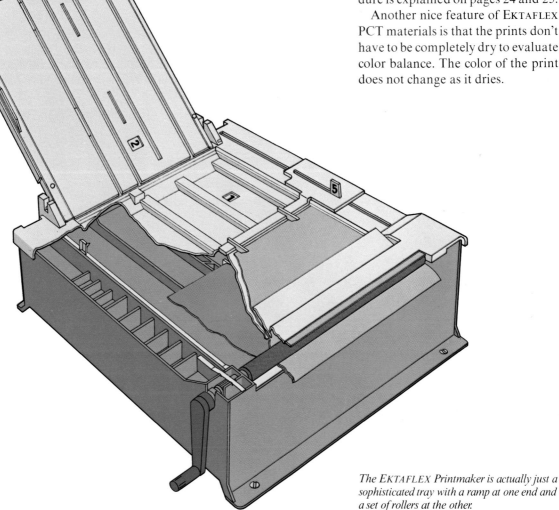

The EKTAFLEX Printmaker is actually just a sophisticated tray with a ramp at one end and a set of rollers at the other.

EKTAFLEX PCT FILM

You can buy EKTAFLEX PCT film in 8 x 10 in. (20.3 x 25.4 cm) and 5 x 7 in. (12.7 x 17.8 cm) sizes.

If you want to make prints from slides, get the reversal film. For prints from negatives, buy the negative film.

The reversal film must be handled in total darkness. The negative film can be handled under a KODAK safelight filter No. 13 (amber) with a 7½ watt bulb at least 4 feet (1.2 metres) away. But this safelight is so dim that you're just as well off working in the dark.

For ease of handling, the film is notched: when the emulsion side is facing you, the code notch on the top edge at the right.

High temperatures and humidity can spoil the film. Store the unexposed sheets in a cool place (50°F [10°C] or lower) in the original packaging. To avoid condensation on unexposed film, allow the film package to warm up to room temperature before opening. Close the foil bag

after removing each sheet. This is particularly important. If the EKTAFLEX PCT film is left out of the bag for extended periods, it may dry out and curl excessively. Curly film is hard to handle and may not laminate properly.

The emulsion of the film is facing you when the code notch is on the right side of the top edge.

EKTAFLEX PCT PAPER

The same paper is used with negative and reversal film. It makes no difference which film you use. EKTAFLEX PCT paper is available in sizes corresponding to the film, and in two surface finishes: F (glossy) and N-smooth (matte). The paper is *not* sensitive to light and can be handled in room light. But, just like the film, the paper must be kept in the original bag until you use it. This prevents the paper drying out and not laminating properly.

EKTAFLEX PCT ACTIVATOR

The activator solution which starts the processing in the film is used as is, right out of the bottle at room temperature. But, because the solution is highly caustic, you should be careful with it. If you're sloppy, wear rubber gloves, protective clothing, and goggles, or some eye protection when you are pouring it. If you do get it on yourself, wash it off with plenty of soap and water.

The activator has a working life of about 72 hours when exposed to air in the Printmaker or about 75, 8 x 10 in. prints per 3 quart container. At the end of each printing session, drain the Printmaker and store the activator in a sealed bottle. You can keep it like this for up to a year before it spoils.

PREPARING THE PRINTMAKER FOR PROCESSING

Before starting a printing session in your darkroom, you must follow the basic preliminary procedures to set up the Printmaker for use.

Your Printmaker must be on a firm level surface such as a table or bench top for use. It can be secured to the surface by means of screws or c-clamps. EKTAFLEX PCT activator is sold ready-mixed, just pour it into the Printmaker to the level marked on the fill posts. After use, the Activator should be drained out of the tray. Take special precautions when handling the chemical. It is very caustic and any spills or splashes should be quickly cleaned up. Avoid all contact with skin and eyes.

After the Printmaker is filled, place a sheet of EKTAFLEX PCT paper emulsion (white) side down on the Printmaker shelf. This is the last step before turning off the lights and exposing the film.

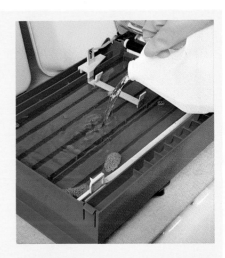

Fill the Printmaker with Activator solution to the marked levels. Wear rubber gloves and protective clothing. The activator is very caustic.

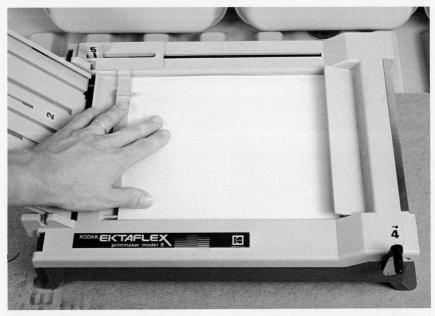

Place one sheet of EKTAFLEX PCT paper emulsion-side (white side) down on the Printmaker tray. The left edge of the paper must be under the prongs of the paper advance rake.

EXPOSING EKTAFLEX PCT NEGATIVE FILM

To make good-looking, pleasing prints you need to start with properly exposed negatives. It's the old gar-bage-in garbage-out situation. Lousy negatives can only give you lousy prints. So begin by choosing a prop-erly exposed negative. Ideally, the subject should include a broad range of tones and colors, with perhaps some sky or grass, or flesh tones, pale colors or grays.

These colors are sensitive to small filtration changes and they are easy to remember. When working from neg-atives, you don't have the original subject to check the color against so you'll be relying on your memory, the color balance series, and the exam-ples on pages 30 and 31. A people picture like the one shown is ideal.

The easiest negative to work with is one that includes a gray card. Then you can use the KODAK EKTACOLOR FilterFinder Kit to help you determine the best exposure and filtration. See page 34 for an explanation of how the filterfinder works.

Be sure the gray card is large enough in the image so you'll have enough room for the FilterFinder on your print.

Notice how color negatives have an overall orange-brown cast and tones and colors are reversed, so that light parts of the subject are dark and dark parts, light. An overexposed negative appears dark, with little detail in the subject; an underexposed negative is pale and detail, especially in the shadows, has been lost.

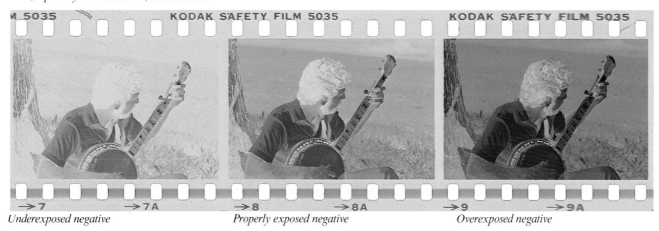

Underexposed negative *Properly exposed negative* *Overexposed negative*

Making the first exposure

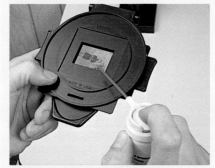

1. Clean the dust off the negative handling it by its edges only, then place it in the negative carrier of the enlarger, **emulsion side up** (lettering and numbers appear backwards from the emulsion side).

4. Dial-in a starting filtration of 40M (magenta) and 40Y (yellow) or put in the equivalent filters. Then set the lens at *f*/11 and turn off the enlarger, switching the timer to "expose."

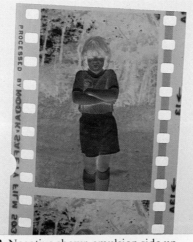

2. Negative shown emulsion side up. Note that the numbers on the edge of the film appear backwards.

5. Remove the scrap paper and replace it with a sheet of EKTAFLEX PCT negative film, emulsion side up (the notched edge should be at top right).

The black square in the upper left hand corner of the illustration indicates that step is done in the dark.

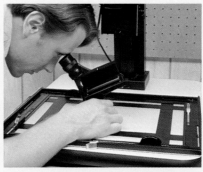

3. Turn out the room lights, turn on the enlarger by switching the timer to "focus," and open the enlarger lens all the way. Compose and focus the image on a piece of paper about the same thickness as EKTAFLEX PCT negative film (an old, exposed sheet will do) positioned on the easel. Use a focus magnifier for fine focus adjustments.

6. Make a series of 5-second test exposures across the film. Use a piece of card to cover all but about an inch of the film for the first five seconds, then move the card to uncover another inch and expose again. Continue until the entire sheet has been exposed.

EXPOSING EKTAFLEX PCT REVERSAL FILM

Begin by choosing a slide that was properly exposed, one that is neither too dark or too light. Since you will be trying to match the original slide, it isn't as important to begin with a slide that includes a broad range of tones and colors as it is when printing negatives. But it is important to start with a slide that is not too contrasty. Slides contain more tonal detail than can be reproduced on paper, so a contrasty image (one that has both delicate highlights and deep shadows) will lose some of its tonal range in printing. The highlights may go paper white or the shadows may be totally black. Either way, the print will not be as good as the slide. For best results, print slides that aren't too contrasty.

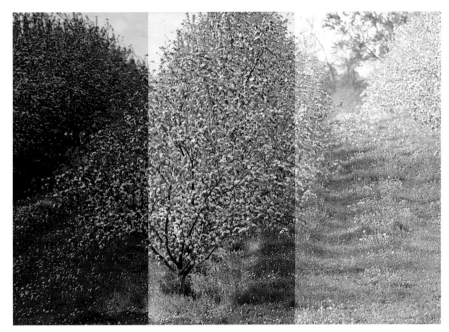

Underexposed slide *Properly exposed slide* *Overexposed slide*

An obvious advantage in printing from slides is that you have a positive original as a starting point. Tones and colors are not reversed and you can tell from the start quite easily if it is good enough for printing.

Making the first exposure

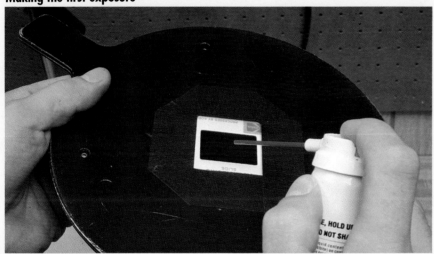

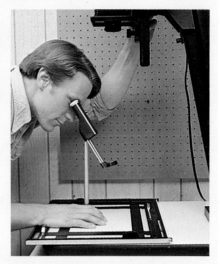

1. Clean the dust off the slide. Handling the film by its edges only, place it in the negative carrier of the enlarger, **emulsion side up** (lettering and numbers on the film appear backwards from the emulsion side). The emulsion side of a mounted slide is the one that says KODACHROME or EKTACHROME.

2. Turn off the room lights, turn on the enlarger by switching the timer to "focus" and open up the lens all the way. With a piece of scrap paper about the same thickness as EKTAFLEX PCT reversal film under the easel (an old, exposed sheet will do), compose and focus the image. Use a focus magnifier for fine adjustments.

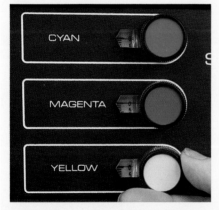

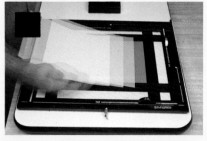

3. Turn off the enlarger. Dial-in the starting filtration, or put in the required filters. Use the filtration recommended in the instructions packaged with the film. Then set the lens as recommended and switch the timer to expose.

4. Remove the scrap sheet and place a sheet of EKTAFLEX PCT reversal film in the easel emulsion-side up (the notched edge should be at top right).

5. Turn on the enlarger and make a series of test exposures across the film. Using a piece of card, expose about an inch of the film at a time. Then move the card to uncover another inch and expose again. Continue until the film is completely exposed.

If you have a carrier for your enlarger that will hold mounted slides, use it. If you don't have one then you'll have to either take the film out of the mount or work something else out. (You can use a 2¼ square carrier to hold mounted slides by putting them in diagonally so the carrier holds the corners. Then tape up the top plate of the carrier so no light leaks around the edges of the slide.)

PROCESSING EKTAFLEX PCT FILM

Exactly the same processing procedures are followed whether you are using negative film or reversal film. Before starting, prepare the Printmaker by filling it with activator solution and place one sheet of EKTAFLEX PCT paper emulsion side (white side) down on the paper shelf. (After adding the solution, close the top of the Printmaker gently. If you slam it, the activator will slosh out all over everything.) The remaining processing steps take place in total darkness (or under safelight only if you're using negative film), until the film and paper are laminated.

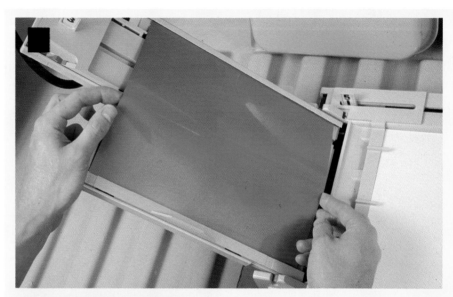

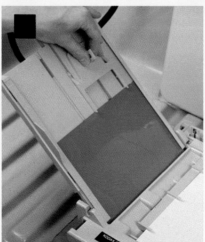

1. After exposure, place the exposed film, emulsion side up (the notch at top right) on the film loading ramp.

2. Move the ramp slide smoothly downward so that the film enters the activator solution inside the Printmaker. Return the slide to its former position at the top of the ramp.

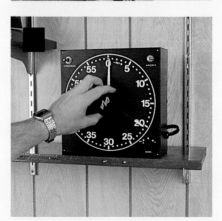

3. Immediately turn on the timer.

4. Just before the soak time is over, begin turning the crank clockwise.

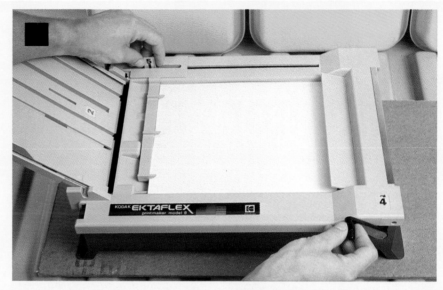

5. When the soak time is over move the film advance handle slowly toward the rollers until you feel the rollers pulling the paper and film.

6. Continue turning the crank until the laminated film and paper are cranked out of the Printmaker. Crank smoothly and steadily. Jerky cranking will cause stripes on the print.

7. Look at your watch or the clock and note the time. You can write the time that the print was cranked out of the Printmaker on the back of the print but do so very gently. The lamination is pressure sensitive and is best handled only by the edges. If you do want to write on it, use a soft, felt-tipped pen.

Temperature/Processing Time
As with all processing and printing, consistent conditions will give you consistent results. Soak time and lamination time should be determined by your room temperature following the table.

Room temperature		Activator soak time	Lamination time
°F	°C	seconds	minutes
65	18	20	8–15
70	21	20	7–12
75	24	20	6–10
80	27	20	6–10

This information is subject to change. Check the instruction sheet packaged with the film for the latest recommendations.

8. When the film and paper have been laminated together long enough *(see table)*, peel them apart.

9. Color and density can be judged as soon as you peel the lamination apart. It is not necessary to wait until the print dries.

10. Never wash the print, as this can affect the dyes, and like all resin coated (RC) papers, EKTAFLEX PCT paper should never be ferrotyped.

25

Analyzing your results:
Prints from negatives

*After you peel the film and paper apart, you can immediately begin
to evaluate the color balance and exposure. Don't be dismayed
if your first prints need both the color and the exposure adjusted.
It is to be expected.*

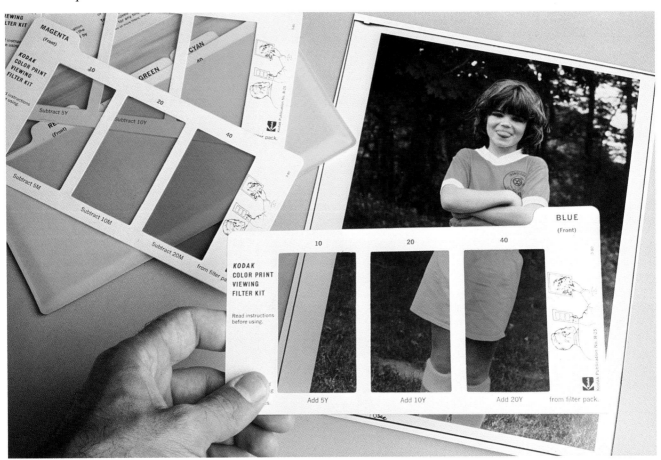

Learning to adjust exposure and filtration, particularly when printing negatives, is one of the printing skills you will develop with experience. Initially, it is always best to make at least one test strip of varying exposure times to narrow down exposure and filtration for a proper print.

Exposure time and filtration are the two main variables in color printing. When analyzing your results it is easier to deal with them one at a time, beginning with exposure.

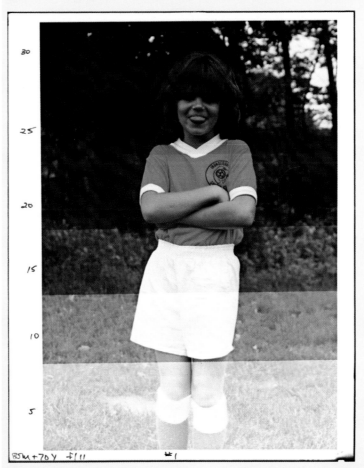

Your processed test strip should look something like the print shown above. As you can see, there are several distinct bands of exposure, varying in density from light to dark. Each band corresponds to an exposure time: the lightest being the band that received only five seconds exposure. Look at the shadow areas in each band. Are they too dark? Has a lot of detail been lost? Look at the highlights. Are they bright and clear, or are they pale and "washed out"?

Decide which band looks best and figure out how many seconds exposure it received. (If it's the third lightest, it got 3 x 5, or 15 seconds, exposure.)

When you've picked on the best exposure time, set the timer accordingly.

Record the exposure information. (Don't skip this. It is very important. It will prevent much frustration and confusion later on.) Write the exposure and filtration on the print. And also number the print.

Prints made using EKTAFLEX PCT *Negative film have the characteristic border shown. It is caused by light leaking between the film and paper lamination and can be trimmed off when the print is dry.*

Problems:
If your print is absolutely white, you probably exposed the film upside down (from the back). Make sure the notch is in the right place and try again.

If your print is very faint, it is underexposed. Open the enlarger lens 2 stops and try again.

If your print is so dark that it is almost black, it is overexposed. Close the lens down 2 stops and try again.

If the exposure is OK but the color needs correction, read on.

COLOR BALANCE

To evaluate the color balance of your print, use the KODAK Color Print Viewing Filter Kit. Then adjust the filtration in the enlarger accordingly.

If you find you are having trouble finding a filter that properly corrects the color, try concentrating on midtones like grays, pastels, or skin. These colors are very sensitive and readily show small filtration errors.

Avoid evaluating color balance under fluorescent light if you can. Most fluorescent lights, particularly the common cool white, have poor color rendition. They make everything look green. Look at prints under natural daylight or regular tungsten bulbs.

KODAK Color Print Viewing Filter Kit (Kodak Publication No. R-25). These are actual color filters that you look through to see what a filtration change would do to your print. You can actually see what your print will look like if you add or subtract a specific filter.

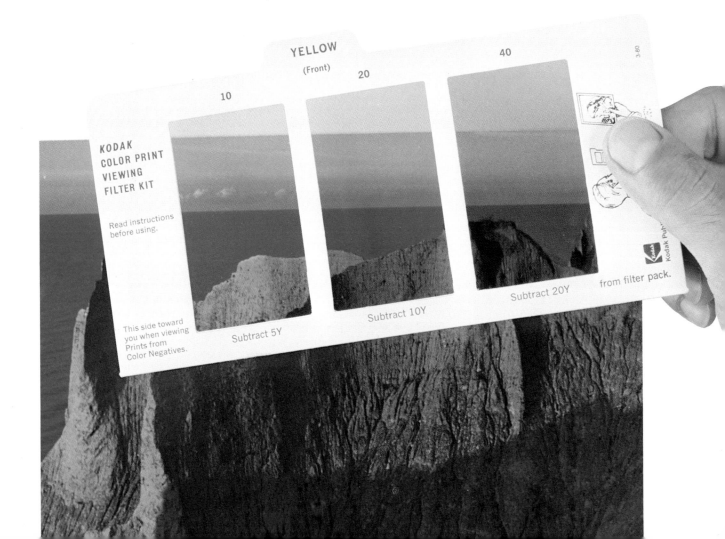

An alternative to using the viewing filters is the KODAK EKTACOLOR FilterFinder Kit. The filterfinder works effectively because it gives you 96 different filtration alternatives on the same print. The section on pages 34 and 35 explains how the filterfinder works.

A second alternative is an electronic analyzer. If you are an experienced color printer and you are continually printing similar negatives, like portraits for example, then an analyzer can be very valuable.

An analyzer is useful for repeating what you have already produced. First you have to make a perfect print by trial and error.

Then you program the analyzer so you can exactly reproduce a specific color in that print. This works very well for pictures of people since you can use the analyzer to match the color of their skin. But it is nearly useless if you make a perfect print of a sunset and then want to print a closeup of a flower.

29

COLOR BALANCE SERIES—
PRINTS FROM NEGATIVES

These examples give you some indication of the amount of change you can expect to get in a print with a specific change in filtration or exposure. The information under each image gives the filtration or exposure change required to correct that image to normal.

Add 40Y and 40C or Subtract 40M

Add 40Y and 20C or Subtract 40M and 20C

Add 40C and 20Y or Subtract 40M and 20Y

Add 20Y and 20C or Subtract 20M

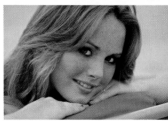

Add 20Y and 10C or Subtract 20M and 10C

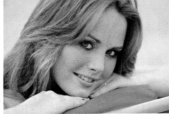

Add 20C and 10Y or Subtract 20M and 10Y

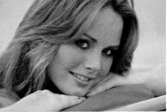

Add 10Y and 10C or Subtract 10M

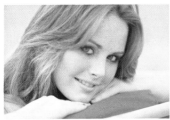

Add 40C or Subtract 40M and 40Y

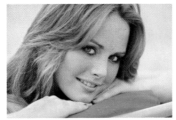

Add 20C or Subtract 20M and 20Y

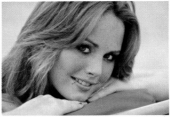

Add 10C or Subtract 10M and 10Y

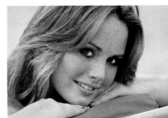

Normal

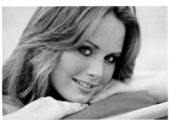

Add 20C and 10M or Subtract 20Y and 10M

Add 10M and 10C or Subtract 10Y

Add 40C and 20M or Subtract 40Y and 20M

Add 20M and 20C or Subtract 20Y

Add 20M and 10C or Subtract 20Y and 10C

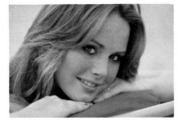

Add 40M and 40C or Subtract 40Y

Add 40M and 20C or Subtract 40Y and 20C

EXPOSURE SERIES

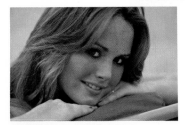

Add 40Y or Subtract 40M and 40C

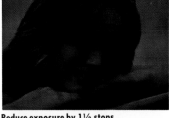

Reduce exposure by 1½ stops

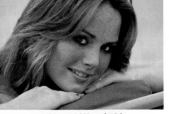

Add 20Y or Subtract 20M and 20C

Add 40Y and 20M or Subtract 40C and 20M

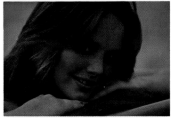

Reduce exposure by 1 stop

dd 10Y or Subtract 10M and 10C

Add 20Y and 10M or Subtract 20C and 10M

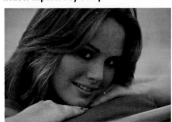

Reduce exposure by ½ stop

dd 10M and 10Y or Subtract 10C

Add 20M and 20Y or Subtract 20C

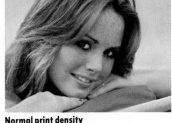

Add 40M and 40Y or Subtract 40C

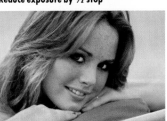

Normal print density

Add 10M or Subtract 10Y and 10C

Add 20M and 10Y or Subtract 20C and 10Y

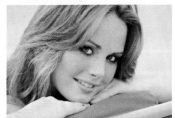

Increase exposure by ½ stop

Add 20M or Subtract 20Y and 20C

Add 40M and 20Y or Subtract 40C and 20Y

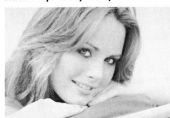

Increase exposure by 1 stop

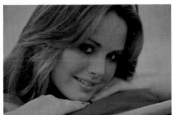

Add 40M or Subtract 40Y and 40C

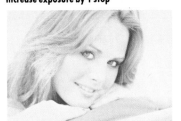

Increase exposure by 1½ stops

WHAT GOOD COLOR BALANCE LOOKS LIKE

If you are using the color print viewing filters and are having some trouble remembering exactly the color you are looking for, here are some examples of proper color balance you can use for comparison.

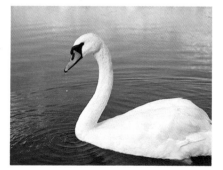

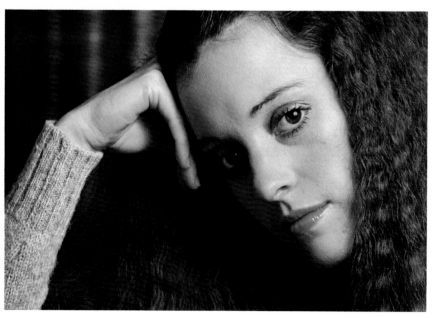

THE KODAK EKTACOLOR FILTERFINDER KIT

The KODAK EKTACOLOR FilterFinder Kit is perhaps one of the most useful darkroom accessories you can buy. It can save you much time and frustration and at the same time quickly pay for itself in material saved.

If you're printing using only the color balance series, you may need to make 7 or 8 prints before you get a good one. The filterfinder will get you to a good print in only 2 or 3 tries. This can be quite a savings, both in time and in materials.

The reason the filterfinder works so effectively is that it eliminates the guesswork from printing. Each test print made with the filterfinder tests 96 different filtrations. (That's twice as many filtration alternatives as the entire color balance series on pages 30 and 31.) All you do is pick out the one that is gray and you've got the right filtration figured out.

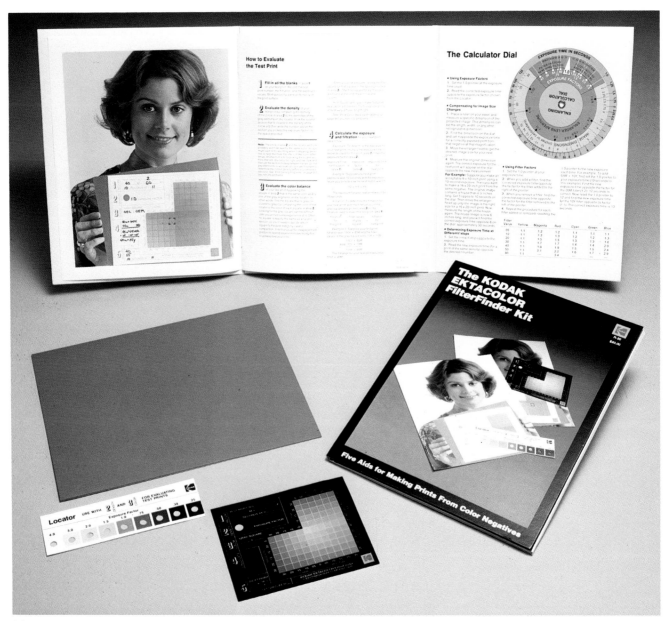

HOW TO USE THE KODAK EKTACOLOR FILTERFINDER KIT

The filterfinder kit can only be used for making color prints *from color negatives.* It cannot be used for making a color print from a color slide.

Used according to directions, the filterfinder kit allows you to determine filtration and exposure quickly and easily. In addition, the filterfinder kit provides you with the means to analyze negatives *by the roll* instead of individually, make routine control checks, zero in new paper emulsions, correct various light sources to daylight, and more.

The filterfinder kit performs much the same functions as an electronic analyzer, but at a much lower cost.

1. Photograph the gray card. *The first step in using the filterfinder kit is to include the gray card in the scene you are photographing. The gray card negative will serve as an accurate record of the exposure and light in the scene you photographed to help you when making the print. Fill at least half of the frame with your gray card image.*

2. Make test prints. *Place the filterfinder on the film in the area where the gray card image will be projected during exposure.*

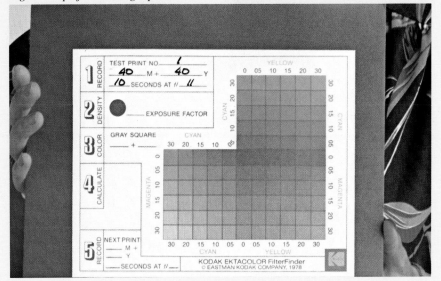

3. Evaluate density and color balance. *After processing the print, use the Locator, first to evaluate density by finding the section of the Locator that matches the density of your test print (see above left). Write the "exposure factor" in the space provided.*

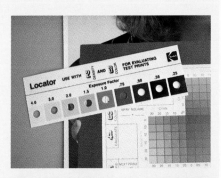

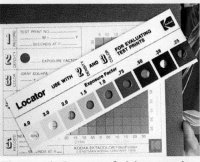

Then, use the Locator to find the square that is gray or closest to gray. When you pick a square, record the filter values for that square in the space provided.

4. Calculate exposure and filtration for your next print. *Once you have "located" the density and color balance of your test print you'll have the information you need to calculate the exposure and filtration corrections necessary to make your next print even better. Complete instructions on how to calculate this information are given in the booklet that is included with the filterfinder kit. When you have made an acceptable test print, you will be able to use the same exposure and filtration figures for printing other negatives exposed under similar lighting conditions.*

How to Make Proof Prints

Proof prints can become your filing system for color images. You make proof prints after you have determined proper exposure and filtration for a group of color negatives or slides (all, presumably, exposed on the same film and under similar lighting conditions.)

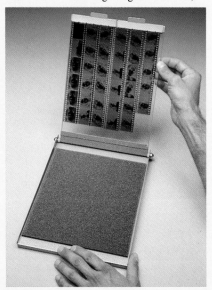

1. Place negatives emulsion side up in the proofer.

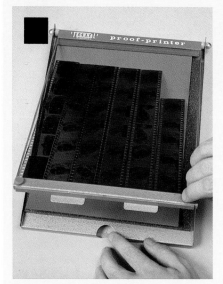

3. Place a sheet of film in the proofer, cover and expose.

Each proof print, then, is actually a contact proof of several related negatives or slides. By making proof prints in the early stages of a color printing session, you can more easily decide which negatives or slides you wish to enlarge, thus saving time and wasted materials.

2. Set the filtration and exposure time based on your experience with your test prints.

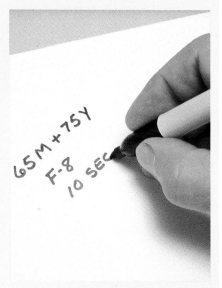

4. After processing and drying, record exposure information on front or back of the print using the felt tipped pen. Then use the proof print to edit your images for enlargement.

HOW TO INTERPRET PROOF SHEETS

1. *Underexposure—the image is dark with little detail. Don't waste your time and materials on trying to make a good print from such a negative.*

2. *Overexposure—the image is very faint. If it's not too far overexposed, you may be able to get a good print from the negative but you'll probably have to adjust the filtration to get proper color balance.*

3. *Light fogging—sometimes when you load your camera in bright light the film at the beginning of the roll gets fogged. Don't try to make a print from negatives like these.*

4. *Poor composition—no problem. It's easy to square up the horizon when you make a print.*

5. *Fuzzy image—either the camera moved or it wasn't carefully focused. Not a candidate for enlargement.*

Analyzing your results: Prints from slides

After you peel the film and paper apart, you can immediately begin to evaluate the color balance and exposure. Don't be dismayed if your first prints need both the color and the exposure adjusted. It is to be expected.

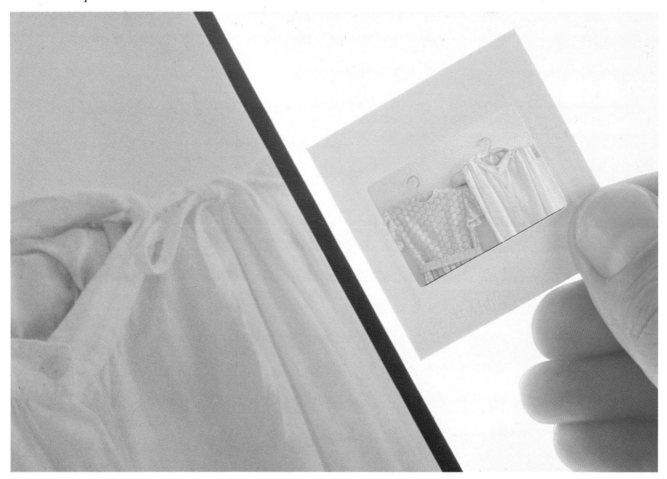

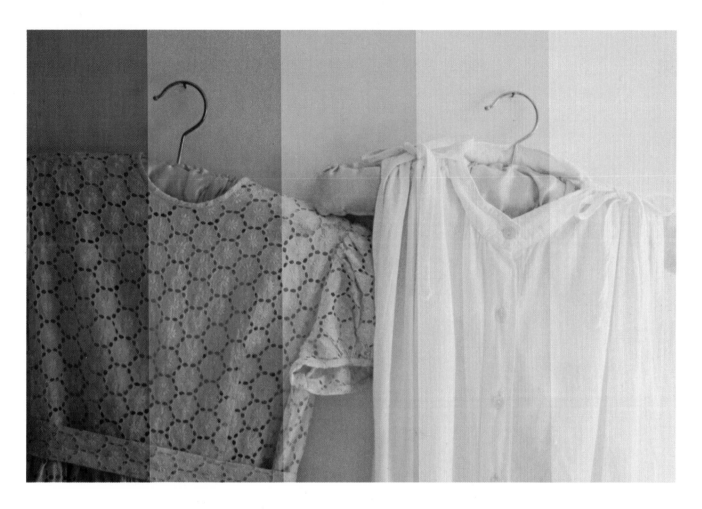

After you peel the film and paper apart, you can immediately begin to evaluate color balance and exposure. Evaluating a print made from a slide is somewhat easier than comparing a print and a negative because you can compare your print to the original slide. As in all color printing, you should view your results in similar, or the same, lighting conditions to those under which they will normally be viewed.

Your processed test strip will look something like the print shown above with distinct bands of exposure ranging from dark to light.

Write the exposure and filtration used right on the print. Also number the print. Write it on the front if you have room, otherwise use the back.

As the test strip shows, exposure works in the exact opposite way from color negative printing. The light bands were given longer exposures than the dark bands, and the dark bands received less exposure. In other words, the longer the exposure, the lighter your print will be, the shorter the exposure, the darker it will be.

Using your original slide as a guide, first try to determine the exposure band that seems nearest to being correct, one that is neither too dark nor too light. Don't be distracted by what appear to be incorrect colors in each band, they can be corrected in the next step; look at the shadows in the print, are they too dark or too weak and faint? Compare them against your original slide. Are the highlights pale and "washed out" or do they closely match your original?

Once you have evaluated the exposure time, you can begin to judge the color balance in your print and assess your filtration.

39

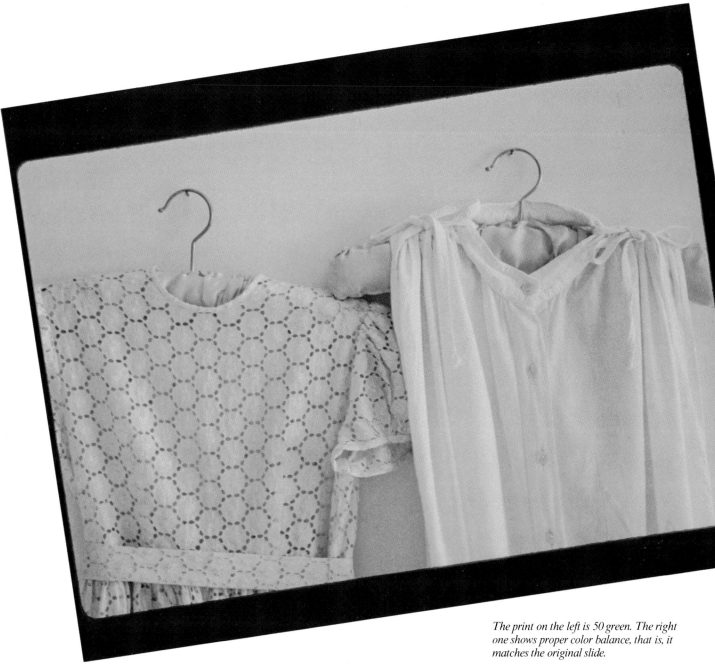

The print on the left is 50 green. The right one shows proper color balance, that is, it matches the original slide.

Because your starting filtration was only an estimate, it is almost certain that you will have to make some adjustments to correct the color in your print. Determining the proper filtration adjustment in each case is perhaps the most difficult part of color printing, but you will find that with experience you will develop an eye for subtle color biases and be able to evaluate color more easily.

In contrast with color negative printing, you have a correct original as a standard against which to judge your print.

Because you are working with a positive-to-positive process, filtra-

tion, like exposure, works logically. To remove a color bias, you simply remove that color from your filtration.

Begin judging your print using your original slide as a guide, your viewing filters, and the color balance series on pages 42 and 43. First determine what color(s) is in excess, and by how much.

As you can see, a color cast of 20 in strength is slight and is most evident in the paler colors. (When changing your filtration, you may have to re-calculate your exposure to compensate for any resultant reduction, or increase in the enlarging illumina-

tion. Check the information and table of filter factors on page 48.)

Paler tones and colors in the print will most readily betray color bias, so look at these first, using your original as a standard against which to judge your print.

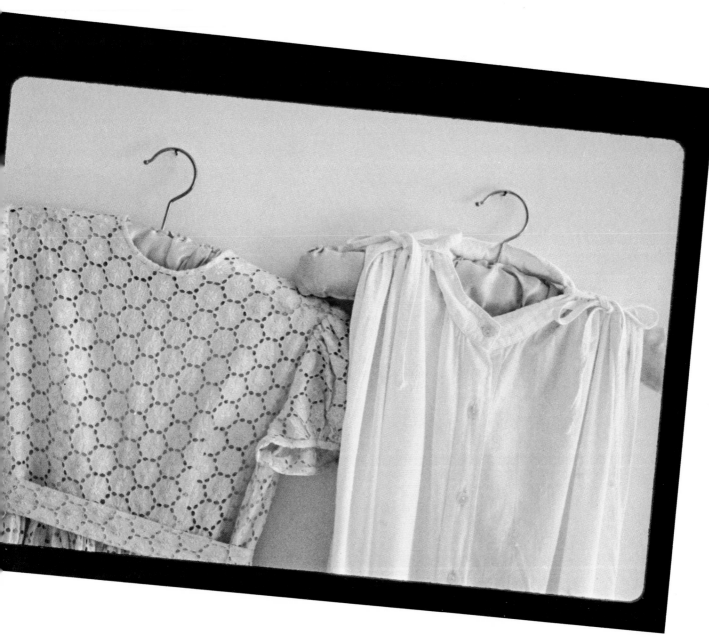

If color balance is:	Do this
too yellow	*remove yellow or add cyan and magenta*
too magenta	*remove magenta or add yellow and cyan*
too cyan	*remove cyan or add yellow and magenta*
too blue	*remove magenta and cyan or add yellow*
too green	*remove yellow and cyan or add magenta*
too red	*remove yellow and magenta or add cyan*

Action	Result
More exposure	*final print lighter*
Less exposure	*final print darker*
Burning-in	*area is made lighter*
Dodging	*area is made darker*
Covered edges	*gives black borders*

See the color balance series on pages 42 and 43 to determine how much filtration to remove or add.

EXAMPLES

**COLOR BALANCE SERIES—
PRINTS FROM SLIDES**
These examples give you some
indication of the amount of change you
can expect to get in a print with a
specific change in filtration or exposure.
The information under each image
gives the filtration or exposure change
required to correct that image to
normal.

Add 40M or Subtract 40Y and 40C

Add 40M and 20C or Subtract 40Y and 20C

Add 40M and 20Y or Subtract 40C and 20Y

Add 20M or Subtract 20Y and 20C

Add 20M and 10C or Subtract 20Y and 10C

Add 20M and 10Y or Subtract 20C and 10Y

Add 10M or Subtract 10Y and 10C

Add 40M and 40Y or Subtract 40C

Add 20M and 20Y or Subtract 20C

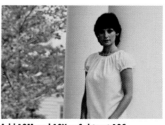
Add 10M and 10Y or Subtract 10C

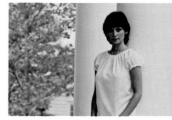
Normal

Add 20Y and 10M or Subtract 20C and 10M

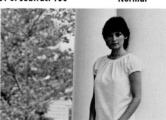
Add 10Y or Subtract 10M and 10C

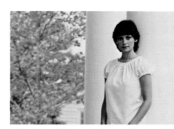
Add 40Y and 20M or Subtract 40C and 20M

Add 20Y or Subtract 20M and 20C

Add 20Y and 10C or Subtract 20M and 10C

Add 40Y or Subtract 40M and 40C

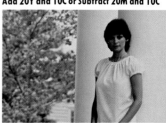
Add 40Y and 20C or Subtract 40M and 20C

42

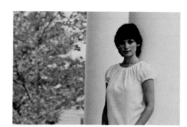

Add 40M and 40C or Subtract 40Y

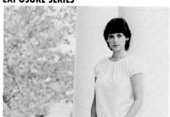

Reduce exposure by 3 stops

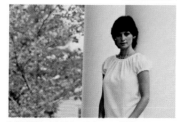

Add 20M and 20C or Subtract 20Y

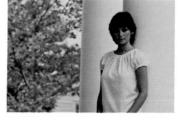

Add 40C and 20M or Subtract 40Y and 20M

Reduce exposure by 2 stops

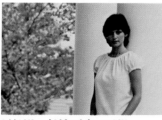

Add 10M and 10C or Subtract 10Y

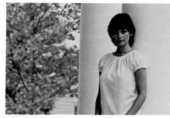

Add 20C and 10M or Subtract 20Y and 10M

Reduce exposure by 1 stop

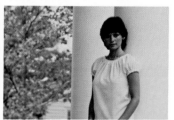

Add 10C or Subtract 10M and 10Y

Add 20C or Subtract 20M and 20Y

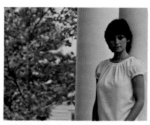

Add 40C or Subtract 40M and 40Y

Normal print density

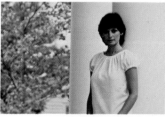

Add 10Y and 10C or Subtract 10M

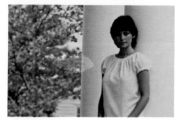

Add 20C and 10Y or Subtract 20M and 10Y

Increase exposure by 1 stop

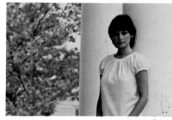

Add 20Y and 20C or Subtract 20M

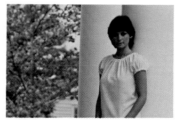

Add 40C and 20Y or Subtract 40M and 20Y

Increase exposure by 2 stops

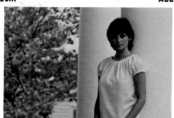

Add 40Y and 40C or Subtract 40M

Increase exposure by 3 stops

43

Additional information

There are certain general principles that apply whether you are printing from slides or negatives.

ADJUSTING PRINT CONTRAST

When you have a slide or negative that has a very wide range of subject tones, ranging from very bright to very dark, it is sometimes hard to choose an exposure that best suits the print. In such a case a compromise is the wisest choice — an exposure that does not lose too much detail in either the shadows or the highlights. In certain cases, however, you may find that you want to try to get the best of both worlds: detail in the highlights *and* detail in the shadows. You may, for example, have taken a portrait of someone in front of a window and want to print as much detail in the sunlit scene outside as in the person's face.

The following pages may not give you the *best* of *both* worlds, but they can help you get about as near to it as possible.

The awning in this print from a slide printed quite light. So we darkened it by dodging the top part of the print.

BURNING-IN

Burning-in, or printing-in is giving additional exposure selectively to parts of the print. After you have made the full exposure, you can give an extra few seconds to one area by shading the rest of the print with your hands or a piece of card, cut to the right shape. If you do this, you should keep your shader close to the projected image and moving so that you don't create a sharp change in density on the print.

Of course, burning-in has entirely opposite results, depending on whether you are printing from slides or negatives.

As shown by the examples opposite, burning-in will *lighten* a dark area, when printing from a slide; burning in a print from a negative will *darken* an area.

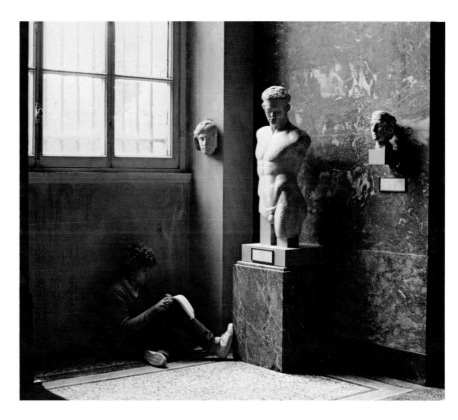

To burn in a small area, cut a small hole approximately the shape of the area to be darkened in a sheet of cardboard, and use the board to keep light from striking other parts of the image.

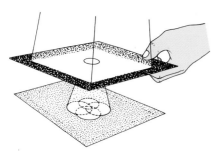

The original negative was very contrasty so we printed for detail in the shadows and then burned in the window, floor, and statue.

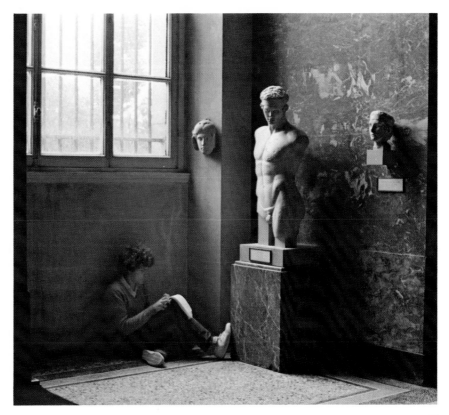

DODGING

Dodging works on the exact opposite principle to burning-in. In dodging, you hold back or reduce light reaching the film (or paper) during exposure in selected areas of the image. This can be done by using simple, homemade dodging tools, such as those shown on this page, made from wire and stiff card cut to the shape of the area you want to dodge.

Again, dodging has completely opposite results depending on whether you are printing from negatives or slides. From negatives, dodging will lighten an area. From slides, it will darken an area.

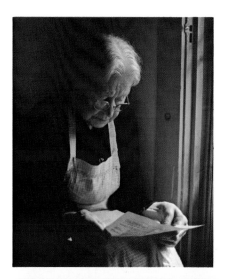

We darkened the edges of this print from a negative by dodging the old woman and her letter and burning-in the edges.

You can dodge either by using your hands or by using cardboard taped to stiff wire.

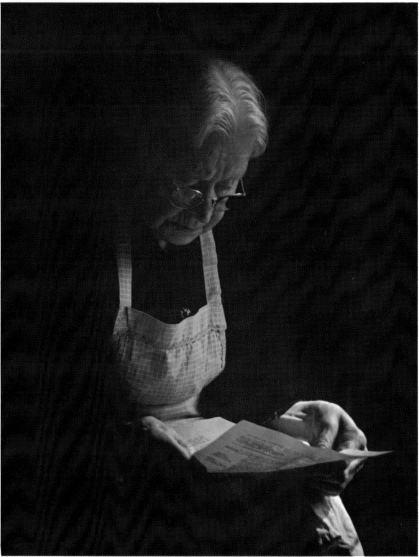

This contrasty scene was actually a studio set. There was a large box light behind the window which gave us glaring highlights and very dark shadows. To reduce the contrast of the negative, we made a shadow mask which is just a sophisticated way of dodging and burning.

The enlarging dial from R-19, the KODAK COLOR DARKROOM DATAGUIDE, will help you make calculations for changing magnification, f/stops, and exposure times. It also has a built-in adjustment for reciprocity for long exposure times.

CHANGING THE FILTRATION MEANS CHANGING EXPOSURE

If you have a color head enlarger, you can forget about this information. Dichroic filters are very efficient and require very little exposure adjustment. Check the enlarger manufacturer's instructions for more information. But if you are using KODAK CC or CP Filters, whenever you change your filtration, you must adjust your exposure time because the changed filtration affects the brightness of the exposing light and the density in your final print. A new exposure time can be calculated simply by using a pen and paper and the table shown here. First, divide your old exposure time by the filter factor of the filter value removed, then multiply the result by the filter factor of the new filter.

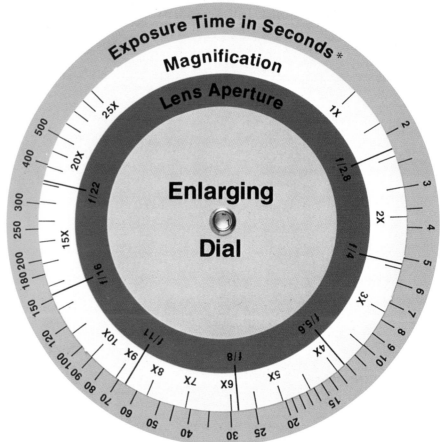

FACTORS FOR KODAK CC AND CP FILTERS

Filter	Factor	Filter	Factor
05Y	1.1	05R	1.2
10Y	1.1	10R	1.3
20Y	1.1	20R	1.5
30Y	1.1	30R	1.7
40Y	1.1	40R	1.9
50Y	1.1	50R	2.2
05M	1.2	05G	1.1
10M	1.3	10G	1.2
20M	1.5	20G	1.3
30M	1.7	30G	1.4
40M	1.9	40G	1.5
50M	2.1	50G	1.7
05C	1.1	05B	1.1
10C	1.2	10B	1.3
20C	1.3	20B	1.6
30C	1.4	30B	2.0
40C	1.5	40B	2.4
50C	1.6	50B	2.9

NEUTRAL DENSITY

You never need to use more than two colors for filtration in the enlarger. Using all three colors unnecessarily lengthens your exposure time. If you are using all three filters, remove the neutral density (unnecessary filtration) by subtracting the lowest filter value from each of the filter values. The final result will give the same filtration but require a shorter exposure time. For example, you can simplify a filtration of 40Y, 40M and 10C to an equivalent filtration by subtracting 10 from each value, giving 30Y and 30M.

CHANGING ENLARGEMENT SIZE

As you raise or lower the enlarger head to change the image size, the brightness of the image is also altered. As you raise the head, for example, the size of the projected image is increased but its brightness is decreased because the same amount of light must cover a greater area. The reverse of this is also true: when you reduce the enlargement, you must reduce the exposure.

To determine your new exposure after changing the enlargement, you can use the following formula:

$$\text{New exposure time} = \text{old time} \times \left[\frac{(1 + \text{new magnification})^2}{(1 + \text{old magnification})^2} \right]$$

Try to keep your exposure times to around 10 seconds or below. If you are printing a very dark negative, or slide, or making a very big enlargement, you can avoid long exposure times by opening your enlarger lens proportionately and reducing the time. A time of 24 seconds, for example, can be halved simply by opening up one full stop.

WHEN THINGS GO WRONG: EKTAFLEX PCT MATERIALS

If your print has not come out looking as it should, don't worry. Even the most experienced printers make lots of lousy prints. The best approach is not to give up in despair, but to relax and find out exactly what went wrong.

If you carefully follow the directions for using EKTAFLEX PCT materials, chances are that you'll never encounter any of these problems. They don't occur very often. Before you go ahead and try to find your problem in the table here, be sure you don't have a simple color balance or exposure problem.

The problem	What happened	What to do
Uneven borders, excess white border at lead end of print.	Paper advanced ahead of film into laminating rollers.	Finger or hand touched plate attached to Printmaker paper rake: grasp advance handle up higher.
Picture crooked on paper, tapered borders.	Paper crooked going into lamination rollers.	Carefully align paper against far edge of Printmaker shelf.
Light colored or white areas at tail of print in image area, sharp or soft edges.	Film not fully immersed in activator at beginning of soak.	Check for low activator level. Push Printmaker film slide quickly and fully to bottom of the ramp.
White or light irregularly shaped patches in print.	Poor lamination.	Store film and paper only in the original sealed bag. Handle laminate carefully.
Film will not slide down ramp smoothly.	Film not loaded properly or wet film-loading ramp.	Make sure film is loaded properly on Printmaker ramp (under edge guides); make sure there is not activator on ramp.
	Film rake in processor not returned fully.	If Printmaker film rake is not fully returned, the rake will interfere with entry of next sheet.

The problem	What happened	What to do
Round plus density spots with soft edges in image area.	Warm fingers touching the lamination caused darkening of the areas touched.	Handle laminate only by the edges.
Magenta edges greater than ⅛ inch wide at edge of film on print from *negative* film only.	Delamination caused by not storing materials properly.	Store materials only as recommended.
Black edges greater than ⅛ inch wide on border of print.	Film emulsion stuck to print because lamination time was too long.	Film emulsion can be rubbed off print with fingers *before it dries*.
Light streaks or patterns in exposed area of print.	Wet lamination rollers left too much solution on film or paper during lamination.	Run a paper towel or blotter through rollers to dry them.
Fine lines across print, often with abrupt changes in print density at the line.	Film inserted unevenly into activator.	Push Printmaker film slide evenly all the way down the loading ramp.
Dark or light bars across full width of print.	Uneven cranking or incorrect gear alignment.	Clean gears, check for damage, crank smoothly.
Blue streaks with sharp edges.	Paper got wet prior to lamination.	Clean and dry Printmaker paper shelf carefully.
Red lines or spots.	Damp prints stacked on top of each other.	Make sure prints are dry before stacking.

Processing Kodak Ektacolor papers

KODAK EKTACOLOR papers are used for making prints from color negatives. The basic procedures for printing color negatives have already been described in a previous section. This section deals with the processing of EKTACOLOR papers in tubes.

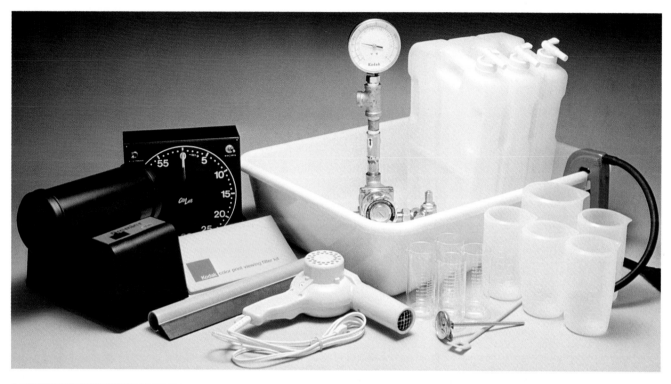

ASSEMBLE THE NECESSARY EQUIPMENT

In addition to the darkroom, enlarger and basic printing equipment described on pages 12–15, you will also need:

Darkroom graduate *(32 oz size minimum)*

Containers for mixing and storing chemicals.
Note: for processing prints from negatives in tubes using a KODAK EKTAPRINT 2 processing kit, you will need 3 separate one-gallon-size containers for mixing and storage.

Containers for premeasured amounts of processing solutions.
Note: for processing 8 x 10-inch prints from negatives in tubes using KODAK EKTAPRINT 2 chemicals you will need four separate containers with 70 mL (2.4 fl oz) minimum capacity each, and 4 containers with 500 mL (17 fl oz) minimum capacity each.

Stirring paddle for mixing chemicals.

Thermometer (a good one, designed for color processing).

Processing tube.

Timer with sweep second hand (to time processing steps on wet side).

Optional-but-nice-to-have category:
Large processing tray, 16 x 20-inch size suggested, the deeper, the better.
Note: you can choose different methods to maintain temperature control during processing. One method requires the use of constant-temperature water bath for the chemicals, and for this method you need a processing tray.

KODAK automatic tray siphon (useful in the constant-temperature water bath method described above).

Rubber squeegee (used to remove excess water from surface of finished prints to speed drying).

Sponge (we all spill things from time to time.)

KODAK Color Print Viewing Filter Kit (for use in evaluating prints).

Thermostatic mixing valve (only if you feel like going top shelf with temperature control).

Hair dryer (used to dry wet prints more quickly than the hang-em-up air-dry method. You'll want one of these almost immediately).

Motorized base for processing tube (Relieves you of the tedious rolling back and forth of the tube during processing. Also helps provide more uniform agitation. You will probably want one of these before your tenth print.)

ASSEMBLE NECESSARY MATERIALS

In addition to the equipment and materials listed on pages 14, 15, and 51, you will also need the following.

CHEMICALS

KODAK EKTAPRINT 2 Processing Kit

This kit contains all chemicals necessary for making color prints from color negatives using KODAK EKTACOLOR 74 RC or 78 paper. The chemicals are all-liquid concentrates you mix to make 1 gallon each of developer, stop bath, and bleach-fix. The capacity of the kit is about 50, 8 x 10-inch prints, or the equivalent in other sizes.

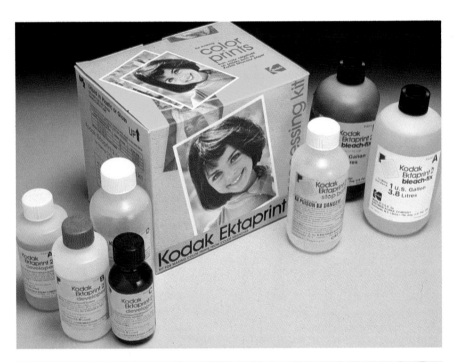

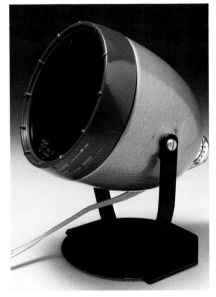

SAFELIGHTS

A KODAK Safelight Filter No. 13 is recommended for EKTACOLOR paper. Keep the paper at least 4 feet from the light. This safelight is very dim and you may find that you are just as well off working in the dark.

KODAK EKTACOLOR 74 RC or 78 Paper.
If you are storing your paper under refrigeration, be sure to remove it from the refrigerator at least two hours before use, to prevent moisture condensation on the cold paper.

PREPARING TO MIX THE CHEMICALS

Completely detailed instructions for
chemical mixing are contained in the
instructions packaged with the
KODAK EKTAPRINT 2 processing kit.
Before beginning any chemical mix-
ing, you should consult these instruc-
tions carefully.

The suggestions on these pages are
simply designed to give you some
practical hints that can help make
your chemical mixing safer and more
efficient.

*Containers can be glass or plastic. Plastic is
preferable for those used in mixing and
processing since they are handled frequently.
Used food or drink containers, plastic or
glass, frequently work well as chemical
containers. But beware of containers that
have been used for soaps, detergents, bleach,
anti-freeze, or other chemicals. Residue could
contaminate your processing solutions.*

RECOMMENDED CONTAINERS

Be sure you have appropriate-sized
containers for mixing, storage, and
processing.

Solution	Mixing	Storage*	Processing**
Developer	**1 wide mouth** min. 1 gal (3.8 L) capacity	**1 narrow mouth** up to 1 gal (3.8 L) capacity	**1 wide mouth** min. 2.4 fl oz (70 mL) capacity
Stop-bath	**1 wide mouth** min. 1 gal (3.8 L) capacity	**1 narrow mouth** up to 1 gal (3.8 L) capacity	**1 wide mouth** min. 2.4 fl oz (70 mL) capacity
Bleach-fix	**1 wide mouth** min. 1 gal (3.8 L) capacity	**1 narrow mouth** up to 1 gal (3.8 L) capacity	**1 wide mouth** min. 2.4 fl oz (70 mL) capacity
Water for prewet and wash			**1 wide mouth** min. 18 fl oz (500 mL) capacity

*Label and number the containers before you
begin using them. For processing containers,
premeasure the required amount of each
solution and indicate the "fill" mark on each
container. Use the same containers for the
same solutions every time you process and do
not intermix them.*

**If you plan to use all of the chemicals in a single darkroom session, there's no need for
storage containers. You can simply pour solutions from the mixing containers as
needed.*

***The amount of solution recommended for processing depends on the size tube you are
using. Consult the table on page 54.*

MIXING

When tube processing, the prewet step before the developer warms up the paper and the tube to the proper processing temperature and softens the paper emulsion to aid developer penetration. However, the water residue from this prewet step dilutes the developer. To compensate for this, *the developer must be specially mixed for tube processing.* Be sure to follow the developer mixing instructions for tube processing. This will result in a solution which is 20 percent more concentrated than a solution prepared following the regular developer mixing instructions.

Read the instructions packaged with the chemicals.

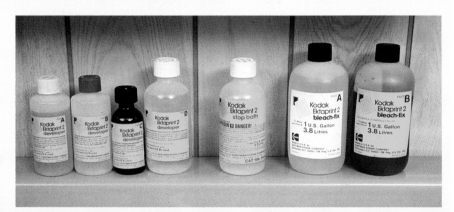

Set up for mixing in an area with adequate ventilation.

Remove the chemicals from the carton and arrange them in the order that you will mix them.

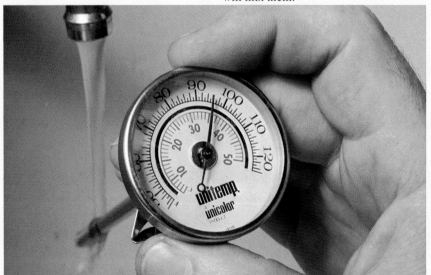

Remember, when adding water to the chemical concentrates, be sure that the temperature of the mixing water is slightly higher [+5°F (+3.0°C)] than the temperature you have determined will be necessary for your water bath. In this way, the chemicals will cool to nearly the same temperature as the water-bath by the time you finish mixing the chemicals, transferring them to processing containers, and placing them in the water bath.

Be careful not to contaminate one solution with another. Wash mixing implements thoroughly between solutions.

SOLUTION AMOUNTS

Tube size	8 x 10 in.	11 x 14 in.	16 x 20 in.
Prewet	17 fl oz (500 mL)	34 fl oz (1000 mL)	51 fl oz (1500 mL)
Developer	2.4 fl oz (70 mL)	4.4 fl oz (130 mL)	8.8 fl oz (260 mL)
Stop Bath	2.4 fl oz (70 mL)	4.4 fl oz (130 mL)	8.8 fl oz (260 mL)
Bleach-Fix	2.4 fl oz (70 mL)	4.4 fl oz (130 mL)	8.8 fl oz (260 mL)
Washes	17 fl oz (500 mL)	34 fl oz (1000 mL)	51 fl oz (1500 mL)

SELECTING A NEGATIVE

For your first print, use a color nega-
tive that you know is capable of
producing a good color print. This
can be a negative that was properly
exposed in the camera, and then
processed and printed by a photofin-
isher. In the beginning, this can serve
as your "guide negative" for proper
color and exposure. When choosing
such a negative, try to select an image
that contains some areas that are
relatively sensitive to minor color-
balance changes (e.g. a scene con-
taining flesh tones, grass, and sky
would make a good "guide
negative").

*Select the negative you will use to make your
first print. For best results, use a negative that
will give you a print that is easy to evaluate.
See page 20 for details.*

EXPOSE THE PAPER AND LOAD THE TUBE

Calculate your starting filtration setting.
For KODAK EKTACOLOR 74 RC or 78
paper, you can use a starting filtration
setting of 50M + 90Y. However, you
will want to adjust this setting based on
the filter data provided on the package
of color paper that you plan to use.

As an example:

Trial starting filtration	50 M	+ 90Y
Filter data on package	–10 M	00Y
Actual starting filtration	40 M	+ 90Y

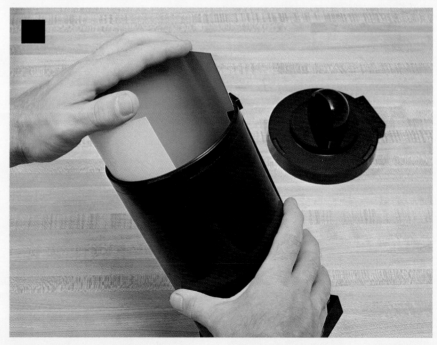

After exposure, still working in
darkness (or under safelight), take the
paper out of the easel and load it into
the processing tube with the emulsion
side (exposed side) away from the tube
wall and facing in. (Loading the tube
can be easier if you practice beforehand
using a scrap piece of paper.) Be sure
the end cap is locked on properly before
continuing.

Turn on the light. You are now ready
to process the print under normal room
lights.

TEMPERATURE CONTROL-VARIABLE TIME

Temperature control is important, because variations in temperature can affect the color and quality of your finished print. And the basic thing to remember here is *consistency*. Each processing step, including agitation, must be done exactly the same way each time you process to achieve predictable results.

You can process EKTACOLOR paper at any temperature between 68 and 91°F (20 and 33°C) if you adjust the processing times accordingly.

Step	Temperature	Time in Minutes	Notes
1. Prewet	Same as developer	½	Use water
2. Developer	See nomograph at left		Developer time depends on the temperature of the solution.
3. Stop Bath	Same as developer	½	
4. Bleach-Fix	80 to 91°F (27 to 33°C) 68 to 79°F (20 to 26°C)	1 1½	Time depends on temperature.
5. Wash		½	The print can be washed either in the tube or in a tray. In a tray, agitate continuously.
6. Wash	68 to 91°F (20 to 33°C)	½	
7. Wash		½	
8. Wash		½	
9. Wipe			Wipe all the water off the print to prevent drying spots.
10. Dry			For fast drying, use a hair dryer but don't get the print hotter than 200°F (93°C).

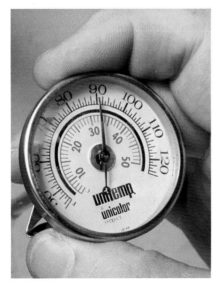

A dial-type thermometer is easy to read and some versions can be clipped to the edge of your water bath tray.

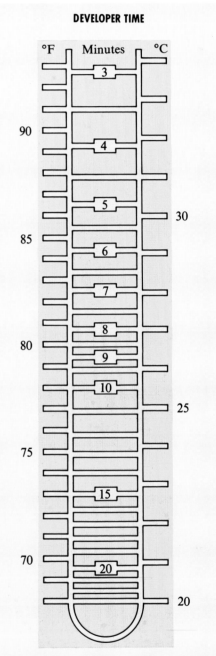

DEVELOPER TIME

Take the temperature of your developer and find the corresponding development time opposite it.

TEMPERATURE CONTROL-DRIFT-BY

The reason this method is called "drift by" is because the recommended temperature of all solutions in this process is 91 ± 0.5°F (32.8 ± 0.3°C). And in order to achieve that effective temperature, you are going to allow the temperatures of your chemical solutions to "drift by" the recommended temperature as they fall during processing. By consulting the room temperature/starting temperature chart below, you'll be able to determine the proper starting temperature that will result in the proper "average" processing temperature as the solutions "drift by" the recommended 91 + 0.5°F temperature during processing.

Using this method, containers holding premeasured volumes of the processing solutions will be immersed in a water bath during the processing cycle.

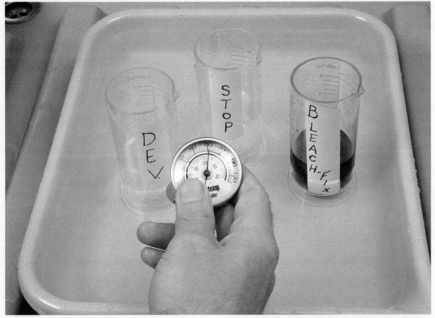

To determine the *starting* temperature of the water bath, consult the room starting temperature chart. The "room temperature" should be the temperature of the room in which you will do your processing. (As an example, if your room temperature is 75°F, the starting temperature of the water bath and all solutions in it should be 99°F. The temperature of the water bath and the solutions will fall during processing, resulting in an average process temperature of 91°F.)

During all phases of this processing method, your processing tube should be used on a flat, level surface. It should *not* be immersed in the water bath even if the tube is water-tight.

Once you have determined the "starting temperature" of your water bath using the chart at right, remember the figure. You will want to keep it in mind when you mix your chemicals, because you'll want your solutions to be at or near the proper "starting temperature" when you immerse them in the water bath.

ROOM/STARTING TEMPERATURE CHART

Determine the temperature of the room in which you will process. Find the closest temperature listed on the left side of chart, then find the recommended starting temperature of the water bath on the right side of the chart.

Room temperature		Water bath starting temperature	
°F	°C	°F	°C
60	15	105	40.5
65	18.5	103	39.5
70	21	101	38
75	24	99	37
80	26.5	97	36
85	29.5	95	35

Typical water bath for "drift-by" temperature control.

PROCESSING

This table summarizes all of the steps necessary for tube processing using KODAK EKTAPRINT 2 chemicals. However, these are the three basic actions that are necessary to complete each step:

pouring in the solution,
agitating the tube, and
draining the solution.

POURING

Begin the timing of each step as you begin agitating the tube.

TUBE PROCESSING STEPS	time in minutes	amount of solution fl oz (mL) per tube size		
		8 x 10 in.	11 x 14 in.	16 x 20 in.
1. Prewet* The prewet step warms the paper and the tube to the proper processing temperature and also softens the paper emulsion to aid developer penetration in the next step.	½	17 fl oz (500 mL)	34 fl oz (1000 mL)	51 fl oz (1500 mL)
2. Developer	3½	2.4 fl oz (70 mL)	4.4 fl oz (130 mL)	8.8 fl oz (260 mL)
3. Stop Bath	½	2.4 fl oz (70 mL)	4.4 fl oz (130 mL)	8.8 fl oz (260 mL)
4. Bleach-Fix	1	2.4 fl oz (70 mL)	4.4 fl oz (130 mL)	8.8 fl oz (260 mL)
5. Wash**	½	17 fl oz (500 mL)	34 fl oz (1000 mL)	51 fl oz (1500 mL)
6. Wash**	½	17 fl oz (500 mL)	34 fl oz (1000 mL)	51 fl oz (1500 mL)
7. Wash**	½	17 fl oz (500 mL)	34 fl oz (1000 mL)	51 fl oz (1500 mL)
8. Wash**	½	17 fl oz (500 mL)	34 fl oz (1000 mL)	51 fl oz (1500 mL)

9. Remove the print from the tube (or from the tray, if you have completed steps 5–8 in a tray) and proceed to the drying and evaluating steps.

*If your tube will not hold the recommended volume of water for this step (as well as for steps 5–8), simply fill the tube with as much water as possible. When you drain the tube following prewet you may see some discoloration of the drain water. This is normal.

**Note: For these four wash steps, you can either fill, agitate, and drain the tube four times, or you can remove the print from the tube following step 4, place the print in a tray of water, and agitate by rocking the tray for 30 seconds. At the end of 30 seconds, dump the water out of the tray and refill. Continue doing this for a total of 4 washes, each 30 seconds long.

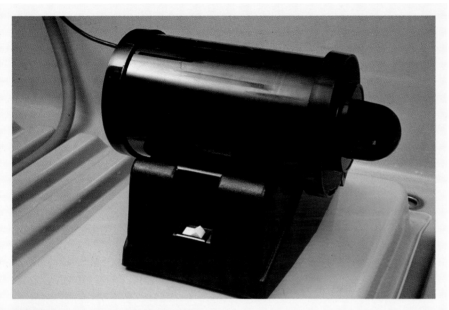

AGITATING

Proper agitation is crucial for adequate processing. Be sure to follow the agitation procedures recommended by the manufacturer of your tube. You may want to consider a motorized roller to take care of agitating the tube for you. They are more consistent than manual agitation and it's less tedious.

DRAINING

At the end of each step shown in the table, drain the solution from the processing tube in preparation for the next solution. The times indicated in the table allow for 10 seconds *between* steps for draining. (For example, draining should take place during the last 10 seconds of the 3½ minutes specified for developer.) A few tests with plain water will tell you whether you need more or less drain time. If so, adjust the times shown in the table. Based on the design of your tube, you may also find that you will need to shake the tube slightly or tilt it 180 degrees from side to side in order to drain it completely.

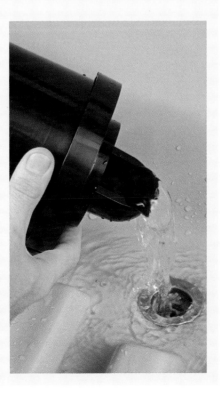

In addition, you'll want to remember the following . . .

Keep your timer close at hand for these processing steps. For the timed interval of each processing step, *start* the timer when you begin to agitate the tube (**not** when you pour in the solution). *Stop* the timer when draining is complete. Then *reset* the timer for the next step.

Check your tube carefully before processing to be sure it is *clean* and *dry*. Cleaning the tube after processing a print helps prevent chemical contamination of solutions and paper. The fastest way to wash out the tube is to use hot water and then dry it out with a bath towel.

Never attempt to reuse chemicals once they have been used to process a print. Also, don't try to process with an insufficient volume of any solution.

Consistency in processing pays off. The color balance and density of your prints are affected by processing as well as by filtration and exposure. To get good quality images you need to process your prints as recommended and you need to do so consistently. Changes in solution times or volumes, temperature variation, and incorrect mixing can all cause unpredictable color and density shifts that will confuse you in trying to arrive at the correct filtration and exposure. However, you can easily avoid these problems by following instructions and processing each print in *exactly* the same way.

DRY AND EVALUATE

Wet prints on EKTACOLOR paper have a slight bluish cast to them and you should never try to evaluate a wet print for color balance. Follow the directions given here for adequate drying. Once your print is dry then you can proceed with evaluation.

Place the wet print, image-side up, on a smooth counter top and use a clean, wide-bladed squeegee to remove excess water from the surface of the print.

There are several ways to dry a print. The one you choose will depend on how much of a hurry you are in to evaluate your print. As examples, you can hang the print from a line, much as you would hang clothes on a line.

You can place the print image-side up on towels or specially designed screen-type drying racks.

Or, perhaps best and fastest of all, you can use a small portable hair dryer or similar hot air source to speed drying time, as long as the temperature does not exceed 200°F (92°C). Above all, *never* ferrotype prints made on RC (resin coated) paper.

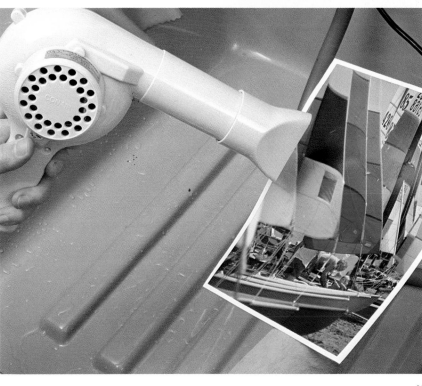

WHEN THINGS GO WRONG

To err is human . . . Everyone makes mistakes. If you've thumbed your way to this page looking for a reason why your print doesn't look quite right, relax. These things happen to the best of printers. The best approach is to stop, take a deep breath, have a cup of coffee, and find out what went wrong. That's what this section is all about.

Appearance of Print	Probable Cause(s)	Recommended Solution(s)
High contrast with cyan stain and/or high cyan contrast (pink highlights with cyan shadows)	Developer too concentrated.	Dilute developer.
	Bleach-fix contamination of developer or prewet.	Toss developer and mix new batch.
	Developer time too long and/or process temperature too high.	Review developer time and process temperature recommendations.
Magenta-blue streaks	Insufficient stop bath action (because stop bath is exhausted, contaminated, or no stop bath was used).	Be sure you included the stop bath step. If you did, dump the remaining stop bath and mix new batch.
Pink streaks or pink fingerprints	Water on print prior to processing (caused by inadequate drying of the tube and cap).	Dry tube and cap thoroughly before inserting exposed paper.
	Emulsion was touched prior to processing.	Handle exposed paper with care.
Light and dark	Prewet not used.	Be sure to include prewet steps.
	Insufficient developer agitation.	Consult agitation recommendations of tube manufacturer.
	Processor tube not level.	Be sure to carry out all processing steps on a level surface.
Bluish looking black tones	Developer too dilute.	Dump developer and mix new batch.
	Developer time too short.	Review recommendations for developer time.
	Drain time after prewet insufficient.	Allow ten seconds drain time after prewet step.
Low contrast with magenta-pink highlights and green shadows	Developer too dilute.	Dump developer and mix new batch.
	Insufficient developer volume and/or agitation.	Review recommendations for developer volume, time, agitation, and temperature.
	Developer time and/or temperature incorrect.	Calculate your starting temperature carefully.
Light crescents	Paper was kinked during handling.	Handle paper carefully when exposing, loading tube, squeegeeing, and drying.
Very light, "washed out" print	Paper loaded into tube with emulsion side facing wrong way.	Load paper with emulsion side toward inside of tube.
White spots or specks	Dust.	Clean negative carefully.

Appearance of Print	Probable Cause(s)	Recommended Solution(s)
Blotches and Spots	Insufficient agitation.	Consult agitation recommendations of tube manufacturer.
	Insufficient stop bath action (because stop bath is exhausted, contaminated, or stop bath was used).	Be sure you included the stop bath step. If so, dump the remaining stop bath and mix new stop bath.
Uniform, deep cyan blue stain	Safelight fog, wrong safelight used, or paper fogged by exposure to red light.	Use a KODAK Safelight No. 13 (amber) with a 7½-watt bulb in a safelight lamp at a distance of at least four feet. Keep safelight exposure to recommended minimum, or handle paper in total darkness.
Color way off and unrealistic	Probably a gross error in calculating your filtration.	Check and recheck your figures. Try again using the recommended starting filtration of 50M + 90Y.
Unexplained density shift from print to print	Faulty timer.	Check your equipment.
	Faulty voltage stabilizer (or no voltage stabilizer).	
Yellowish whites	Paper damage by humidity in storage.	Store paper according to manufacturer's recommendations.
	Paper damaged by condensation because of inadequate warm-up time.	Allow adequate time for paper to reach room temperature after removing from cold storage.
	Low-level, white-light fog.	Check for possible light leaks.
Magenta stain	Developer used beyond the recommended storage life.	Dump developer and mix new batch.
	Insufficient final washes.	Wash prints thoroughly following bleach-fix step.
Colored rings or circles	Glass negative carrier causing Newton's rings.	Use glassless negative carrier or insert glass with anti-Newton-ring properties.

Processing Kodak Ektachrome paper

New EKTACHROME Paper Announced

KODAK EKTACHROME 14 paper was announced as this book was going to press. This paper will replace EKTACHROME 2203 paper but both papers will be available for a time.

EKTACHROME 14 paper offers faster printing speed, improved contrast and color reproduction, and less sensitivity to time and temperature variations in processing. But it also requires different filtration, exposure time, and processing. The same chemicals, KODAK EKTAPRINT R-1000, are used for processing, but some of the solution times are different.

If you have EKTACHROME 14 paper, follow the instructions packaged with it. The information in this chapter applies only to EKTACHROME 2203 paper and while both papers handle essentially the same, you'll need the EKTACHROME 14 paper instructions for starting filtration, exposure, and specific processing recommendations.

KODAK EKTACHROME paper is used for making prints from color slides. The basic procedures for printing color slides have already been described in previous sections. This section deals with the processing of EKTACHROME paper in tubes.

MATERIALS

KODAK EKTACHROME 2203 Paper

If you are storing your paper under refrigeration, be sure to remove it from the refrigerator at least two hours before use to prevent moisture condensation on the cold paper.

This paper must be handled in total darkness. Do not use any safelight.

KODAK EKTAPRINT R-1000 Processing Kit

Contains all chemicals necessary for making color prints from color slides using KODAK EKTACHROME 2203 paper.

The chemicals are all-liquid concentrates you mix to 1 quart each of first developer, stop bath, color developer, bleach-fix, and stabilizer.

The capacity of kit is 12, 8x10 inch prints, or the equivalent in other sizes. Just right for an evening darkroom session.

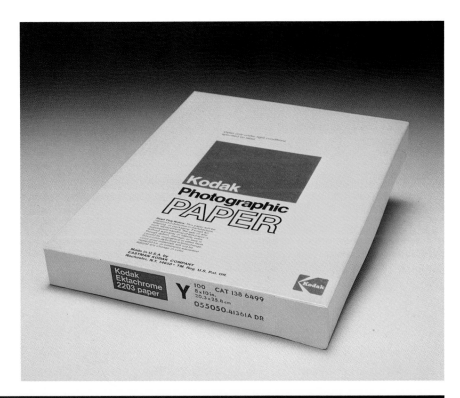

MIXING CHEMICALS

Completely detailed instructions for chemical mixing are contained in the instructions packaged with the KODAK EKTAPRINT R-1000 processing kit. Before beginning any chemical mixing, you should consult these instructions carefully.

The suggestions on these pages are simply designed to give you some practical hints that can help make your chemical mixing safer and more efficient.

Be sure you have appropriate-sized containers as described in the table for mixing, storage, and processing.

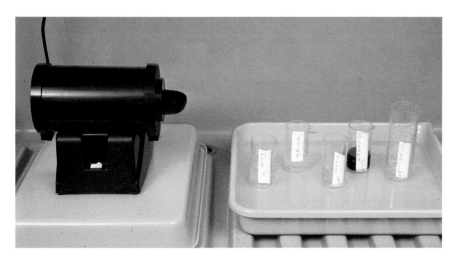

RECOMMENDED CONTAINERS

Solution	Mixing	Storage*	Processing**
First Developer	1 Wide Mouth min. 1 qt (1 L) capacity	1 Narrow Mouth up to 1 qt (1 L) capacity	1 Wide Mouth min. 2.5 fl oz (70 mL) capacity
Stop-Bath	1 Wide Mouth min. 1 qt (1 L) capacity	1 Narrow Mouth up to 1 qt (1 L) capacity	1 Wide Mouth min. 2.5 fl oz (70 mL) capacity
Color Developer	1 Wide Mouth min. 1 qt (1 L) capacity	1 Narrow Mouth up to 1 qt (1 L) capacity	1 Wide Mouth min. 2.5 fl oz (70 mL) capacity
Bleach-Fix	1 Wide Mouth min. 1 qt (1 L) capacity	1 Narrow Mouth up to 1 qt (1 L) capacity	1 Wide Mouth min. 2.5 fl oz (70 mL) capacity
Stabilizer	1 Wide Mouth min. 1 qt (1 L) capacity	1 Narrow Mouth up to 1 qt (1 L) capacity	1 Wide Mouth min. 2.5 fl oz (70 mL) capacity
Water for Prewet and Washes			1 Wide Mouth min. 5 fl oz (150 mL) capacity

*If you plan to use all of the chemicals in a single darkroom session, there's no need for storage containers. You can simply pour solutions from the mixing containers as needed.

**The amount of solution and wash water recommended for processing depends on the size tube you are using. Consult the table on the facing page.

Containers can be glass or plastic. Plastic is preferable for those used in mixing and processing since they are handled frequently. Glass might be more easily broken than plastic containers. Used food or drink containers, plastic or glass, frequently work well as chemical containers. But beware of containers that have been used for soaps, detergents, bleach, anti-freeze, or other chemicals. Residue could contaminate your processing solutions.

Label and number the containers *before* you begin using them. For processing containers, premeasure the required amount of each solution and indicate the "fill" mark on each container. Use the same containers for the same solutions every time you process and do not intermix them.

Before you begin to mix, be sure you have the following:

Stirring paddle
Funnel
Rubber gloves
Water repellent apron
Eye protection

Set up for mixing in an area with adequate ventilation.

SOLUTION AMOUNTS

Step	Tube Size		
	8 x 10 in	11 x 14 in	16 x 20 in
Prewet	5 fl oz (150 mL)	10 fl oz (300 mL)	10 fl oz (550 mL)
First developer	2.5 fl oz (70 mL)	4.4 fl oz (130 mL)	9 fl oz (260 mL)
Stop bath	2.5 fl oz (70 mL)	4.4 fl oz (130 mL)	9 fl oz (260 mL)
Wash	5 fl oz (150 mL)	10 fl oz (300 mL)	19 fl oz (550 mL)
Wash	5 fl oz (150 mL)	10 fl oz (300 mL)	19 fl oz (550 mL)
Color developer	2.5 fl oz (70 mL)	4.4 fl oz (130 mL)	9 fl oz (260 mL)
Wash	5 fl oz (150 mL)	10 fl oz (300 mL)	19 fl oz (550 mL)
Bleach-fix	2.5 fl oz (70 mL)	4.4 fl oz (130 mL)	9 fl oz (260 mL)
Wash	5 fl oz (150 mL)	10 fl oz (300 mL)	19 fl oz (550 mL)
Wash	5 fl oz (150 mL)	10 fl oz (300 mL)	19 fl oz (550 mL)
Wash	5 fl oz (150 mL)	10 fl oz (300 mL)	19 fl oz (550 mL)
Stabilizer	2.5 fl oz (70 mL)	4.4 fl oz (130 mL)	9 fl oz (260 mL)
Rinse	5 fl oz (150 mL)	10 fl oz (300 mL)	19 fl oz (550 mL)

Read the instructions packaged with the chemicals.

Remember, when adding water to the chemical concentrates, be sure that the temperature of the mixing water is slightly higher +5°F (+3.0°C) than the temperature you have determined will be necessary for your water bath. In this way the chemicals will cool to near the water-bath temperature by the time you finish mixing the chemicals, transferring them to processing containers, and placing them in the water bath.

Be careful not to contaminate one solution with another. Wash mixing implements thoroughly between solutions.

Remove the chemicals from the carton and arrange them in the order that you will mix them.

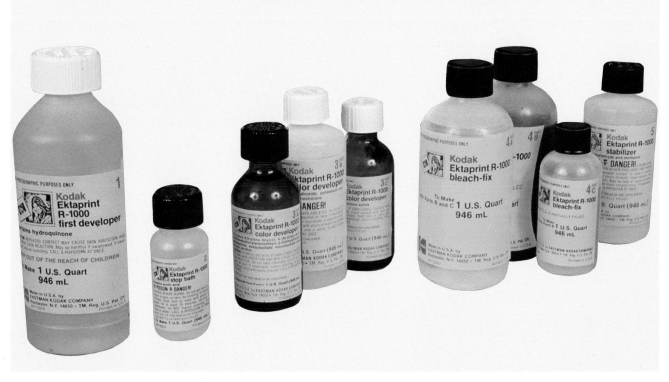

TEMPERATURE CONTROL

Temperature control is important, because variations in temperature can affect the color and quality of your finished print. And the basic thing to remember here is *consistency*. Each processing step, including agitation, must be done at a *constant* temperature.

TEMPERATURE CONTROL—VARIABLE TIME

You can process EKTACHROME 2203 paper at any temperature between 70 and 100°F (21 and 38°C) if you adjust the processing times accordingly.

Step	Temperature	Time in Minutes	Notes
1. Prewet (Wash)	Same as first developer	1	
2. First Developer	See nomograph at the right		Time depends on solution temperature
3. Stop Bath	Same as first developer	½	
4. Wash	Same as first developer	1	
5. Wash	Same as first developer	1	
6. Color Developer	See nomograph at the right		Time depends on solution temperature
7. Wash	70 to 100°F (21 to 38°C)	½	
8. Bleach-Fix	85 to 100°F (29.5 to 38°C)	3	Time depends on solution temperature
	70 to 84°F (21 to 29°C)	4	
9. Wash	70 to 100°F (21 to 38°C)	½	
10. Wash	70 to 100°F (21 to 38°C)	½	
11. Wash	70 to 100°F (21 to 38°C)	½	
12. Wash	70 to 100°F (21 to 38°C)	½	
13. Stabilizer	70 to 100°F (21 to 38°C)	½	
14. Wash	70 to 100°F (21 to 38°C)	¼	
15. Wipe	Wipe all the water off the print to prevent drying spots.		
16. Dry	For fast drying use a hair dryer but don't get the print hotter than 200°F (93°C).		

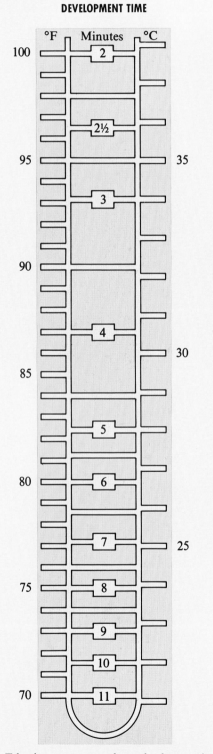

DEVELOPMENT TIME

Take the temperature of your developer and find the corrosponding development time opposite it.

EXPOSE THE PAPER AND LOAD THE TUBE

Select the slide you will use to make your first print. See pages 22 and 23 for information on slides that will print well.

Calculate your starting filtration setting. This table lists Kodak film types followed by a suggested starting filtration setting.

EKTACHROME	25C + 10M
KODACHROME	10C + 05M
Random mix of slides	20C + 10M

However, you will want to adjust these suggested settings based on the filter data provided on the package of color paper that you plan to use. As an example:

Trial starting filtration	25C + 10M
Filter data on Package	–05C + 00M
Actual starting filtration	20C + 10M

After exposure, still working in darkness (or under safelight) take the paper out of the easel and load it into the processing tube with the emulsion side (exposed side) away from the tube wall and facing in. (Loading the tube can be easier if you practice beforehand using a scrap piece of paper.) Be sure the end cap is locked on properly before continuing.

Turn on the light. You are now ready to process the print under normal room lights.

PROCESSING

The table on this page summarizes all of the steps necessary for tube processing using Kodak Ektaprint R-1000 chemicals. However, these are the three basic actions that are necessary to complete each step: **pouring** in the solution, **agitating,** the tube, and **draining,** the solution.

PROCESSING STEPS

Processing Step	Nominal solution temperature of $100 \pm 0.5°F$ ($38 \pm 0.3°C$)	
	Time in Min*	Total Min at End of Step
1. Prewet (water)	1	1
2. First Developer	2	3
3. Stop Bath	½	3½
4. Wash	1	4½
5. Wash	1	5½
6. Color Developer	2	7½
7. Wash	½	8
8. Bleach-Fix	3	11
9. Wash	½	11½
10. Wash	½	12
11. Wash	½	12½
12. Stabilizer	½	13
13. Rinse (water)	¼	13½

*All times include a 10-second drain time (to avoid excess carry-over). Some processing tubes may require a slightly longer drain time. Be sure to allow enough time to make certain the tube is drained and to add the next solution on time for the next step. The next step begins when the solution contacts the paper.

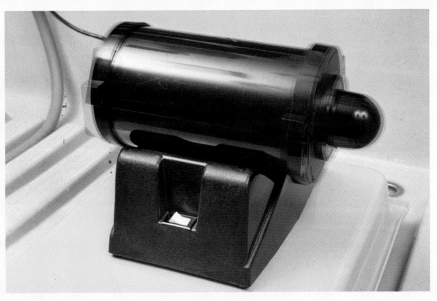

AGITATING

Proper agitation is crucial for adequate processing. Be sure to follow the agitation procedures recommended by the manufacturer of your tube. One common method is shown here. Other methods, including several types of motorized rollers or agitators, will also work. Motorized rollers offer the benefit of relieving you of the tedium of manual agitation.

DRAINING

At the end of each step shown in the table, the solution is drained from the processing tube in preparation for the next solution. The times indicated in the table allow for 10 seconds *between* steps for draining. (For example, draining should take place during the last 10 seconds of the 2 minutes specified for first developer.) A few tests with plain water will tell you whether you need more or less drain time. If so, adjust the times shown in the table. Based on the design of your tube, you may also find that you will need to shake the tube slightly or tilt it 180 degrees from side to side in order to drain it completely. Never attempt to reuse chemicals once they've been used to process a print. Also, don't try to process with an insufficient volume of any solution.

POURING

Begin the timing of each step as you begin agitating the tube.

In addition, you'll want to remember the following . . .

Keep your timer close at hand for these processing steps. For the timed interval of each processing step, *start* the timer when you begin to agitate the tube (*not* when you pour in the solution). *Stop* the timer when draining is complete. Then *reset* the timer for the next step.

Keep your tube level during processing so solutions can work evenly over the surface of the print. This promotes consistent, even development.

Check your tube carefully before processing to be sure it is *clean* and *dry*. Cleaning the tube after processing a print helps prevent chemical contamination of solutions and paper.

Consistency in processing pays off. The color balance and density of your prints are affected by processing as well as by filtration and exposure. To get good quality images you need to process your prints as recommended and you need to do so consistently. Changes in solution times or volumes, temperature variation, and incorrect mixing can all cause unpredictable color and density shifts that will confuse you in trying to arrive at the correct filtration and exposure. However, you can easily avoid these problems by following instructions and processing each print in exactly the same way.

DRY AND EVALUATE

Wet prints on EKTACHROME paper have a slight bluish cast to them and you should never try to evaluate a wet print for color balance. Follow the directions given here for adequate drying, and once your print is dry then you can proceed with evaluation.

Place the wet print, image side up, on a smooth counter top and use a clean, wide-bladed squeegee to remove excess water from the surface of the print.

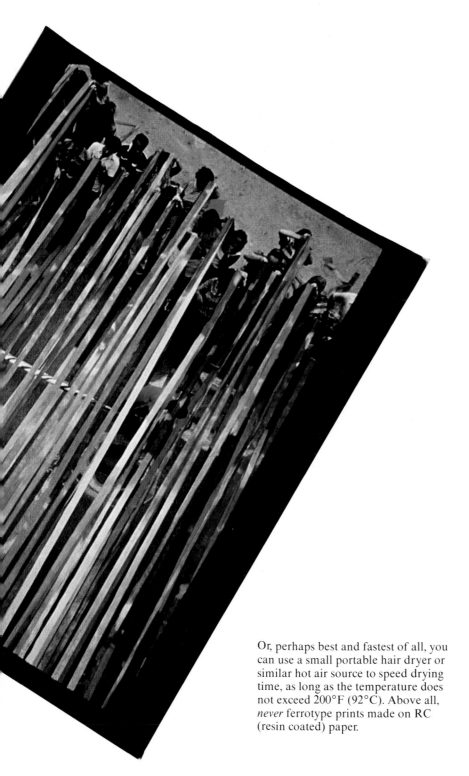

There are several ways to dry a print. The one you choose will depend on how much of a hurry you are in to evaluate your print. As examples, you can hang the print from a line, much as you would hang clothes on a line.

You can place the print image-side up on towels or specially designed screen-type drying racks.

Or, perhaps best and fastest of all, you can use a small portable hair dryer or similar hot air source to speed drying time, as long as the temperature does not exceed 200°F (92°C). Above all, *never* ferrotype prints made on RC (resin coated) paper.

73

WHEN THINGS GO WRONG

To err is human . . . Everyone makes mistakes. If you've thumbed your way to this page looking for a reason why your print doesn't look quite right, relax. These things happen to the best of printers. The best approach is to stop, take a deep breath, have a cup of coffee, and find out what went wrong. That's what this section is all about.

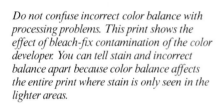

Do not confuse incorrect color balance with processing problems. This print shows the effect of bleach-fix contamination of the color developer. You can tell stain and incorrect balance apart because color balance affects the entire print where stain is only seen in the lighter areas.

Appearance of Print	Probable Cause(s)	Recommended Solution(s)
High contrast with cyan stain and/or high cyan contrast (pink highlights with cyan shadows)	Bleach-fix contamination of first developer or prewet.	Toss first developer and mix new batch.
High contrast with cyan stain	Bleach-fix contamination of stop bath.	Dump stop bath and mix new batch.
Light and dark streaks	Prewet not used.	Be sure to include prewet steps.
	Insufficient first developer agitation.	Consult agitation recommendations of tube manufacturer.
	Processor tube not level.	Be sure to carry out all processing steps on a level surface.
Bluish looking black tones	Color developer too dilute.	Dump color developer and mix new batch.
	Color developer time too short.	Review recommendations for developer time.
	Drain time for wash preceding color developer insufficient.	Allow ten seconds drain time after wash step preceding color developer.

Appearance of Print	Probable Cause(s)	Recommended Solution(s)
Pink streaks or pink fingerprints	Water on the print prior to processing (caused by inadequate drying of the tube and cap).	Dry tube and cap thoroughly before inserting exposed paper.
	Emulsion was touched prior to processing.	Handle exposed paper with care.
High contrast with magenta-pink stain	Bleach-fix contamination of color developer.	Dump color developer and mix new bath.
Light crescents	Paper was kinked during handling.	Handle paper carefully when exposing, loading tube, squeegeeing and drying.
Blotches and Spots	Insufficient agitation.	Consult agitation recommendations of tube manufacturer.
Uniform, deep cyan blue stain	Paper fogged by exposure to light.	Handle paper in total darkness.
Color way off and unrealistic	Probably a gross error in calculating your filtration.	Check and recheck your figures. Try again using the recommended starting filtration for the slides you are printing.
Unexplained density shift from print to print	Faulty timer.	Check your equipment.
	Faulty voltage stabilizer (or no voltage stabilizer).	
Yellowish Whites	Paper damaged by humidity in storage.	Store paper according to manufacturer's recommendations.
	Paper damaged by condensation because of inadequate warm-up time.	Allow adequate time for paper to reach room temperature after removing from cold storage.
Colored rings or circles	Glass negative carrier causing Newton's rings.	Use glassless negative carrier or insert glass with anti-Newton-ring properties.
Very light, "washed out" print	Paper loaded into tube with emulsion side facing wrong way.	Load paper with emulsion side toward inside of tube.
Black spots or specks	Dust.	Clean slide carefully.
Overall "muddy" appearance	Bleach-fix dilute.	Dump bleach-fix and mix new batch.
	Drain time for wash preceding bleach-fix insufficient.	Allow ten seconds drain time after wash step preceding bleach-fix.
	Bleach-fix stored for longer period than recommended.	Dump and mix new batch. Check storage recommendations.

Finishing your prints

Since you've gone through the time and effort to create your enlargements, it's only natural that you'll want to show them off to their best advantage. This chapter gives you the information necessary to do just that.

If you are reasonably careful in cleaning your slides and negatives, you'll have very little problem with dust spots as we've shown here.

*Dust on a slide, **right,** will print as black spots.*

When you're printing a negative, dust will leave white spots on a print.

SPOTTING AND RETOUCHING

Despite the fact that you may have exercised reasonable care in cleaning your slide or negative during printing, you are still likely to see some flaws in your print. Most probably they were caused by dust or dirt, but scratches or other damage to the emulsion might also be culprits. In any event you'll want to remove or minimize these flaws, and spotting or retouching are the best ways to go about it.

Spotting and retouching require simple tools, a steady hand, patience, and some practice. But learning the technique is well worthwhile, because it's usually far less time-consuming to spot or retouch a print than it is to make the print over.

Three methods of spotting and retouching are shown in this chapter. Decide which method or combination of methods is right for your needs. And who knows, you might even develop some techniques of your own! Retouching prints so that the retouching doesn't show requires some practice. You may want to try retouching a couple of scrap prints before attempting to work on a final enlargement.

WET-BRUSH TECHNIQUE FOR SMALL AREAS

This technique is recommended for covering up dust spots and other small blemishes in your enlargements. It requires the use of liquid retouching dyes, available from several manufacturers and sold through photo dealers who normally stock darkroom supplies. No matter which brand you choose, the basic method of applying the dye to prints will be similar to the one shown here. However, it's a good idea to check the manufacturer's recommendations for any specific application techniques and/or dilution requirements which may apply.

MATERIALS NEEDED

Liquid retouching dyes (buy as a set or as individual colors).

Sable brush (#1 or #2).

Palette cup (facilitates mixing and applying of colors; a china saucer will also work).

Blotting paper

Add a touch of "neutral" color to each dye color mixture you plan to use. The neutral dye works to reduce the brilliance of pure colors and makes it easier to blend colors on the print.

Consult manufacturer's data provided with your dyes and mix according to directions. You should be able to use your sable brush for mixing, and mix right in the palette cup.

Be sure to mix a weak dilution of each color/neutral combination for good control. It's easier to add more density to a mixture than to remove excess density.

Remove excess dye from the brush by "rolling" the point as you touch it to the blotting paper. This will serve to shape the brush to a fine point and reduce excessive wetting of the print.

Spot-in the area to be retouched by applying the dye with a "dotting" motion until it matches the tone of the surrounding area and is no longer visible. Be careful to keep the dye within the confines of the spot because any overlapping will result in a dark ring around the spotted area.

If you find that you've added too much dye, soak up the dye immediately with blotting paper.

DRY-DYE TECHNIQUE FOR LARGE AREAS

You can use this method to apply color over large areas of a print. The technique has two major advantages:
1. It allows you the freedom of experimenting until the desired effect is achieved, at which time you can make the effect permanent, and
2. You can use the technique to retouch or spot F-surface color prints without spoiling the glossy finish.

One caution though: the dyes used should be kept *free of water*. Dyes containing water will tend to "set" when applied, making it difficult or even impossible to remove excess or unwanted dye from the print. Any dry dye, on the other hand, can be removed simply by using the reducer.

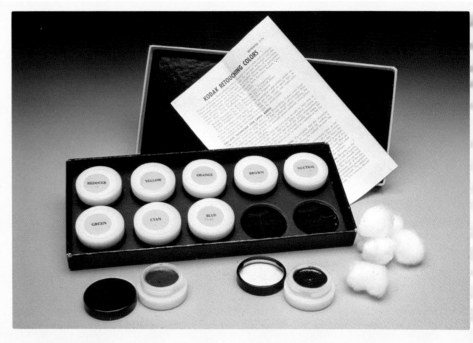

DRY-DYE RETOUCHING

Prepare the print for retouching by thoroughly drying the emulsion surface. This can be done by gently buffing the print surface with a tuft of clean, dry cotton.

MATERIALS NEEDED

A set of Kodak retouching colors, consisting of nine jars of colors (red, green, blue, cyan, magenta, yellow, orange, brown, and neutral), plus a jar of reducer. Individual jars of colors or reducer are also available. Anhydrous denatured alcohol may be used as a substitute for the reducer.

Cotton balls

First, breathe on the cake of retouching color you plan to use.

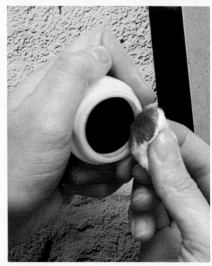

Then pick up a generous amount of dye by rubbing a tuft of dry cotton over the cake of dye.

Using a circular motion, transfer the dye from the cotton to the desired area of the print. For more color, repeat the procedure.

To lighten the applied color over the whole area, or portions of it, continue buffing the surface.

Smooth out the dye by buffing the area lightly with a clean tuft of dry cotton. (You can also use this method to mix two dyes over one area.) Dye on any overlapped areas can be removed later.

When you are satisfied with the effect you have created, it is time to make the dye retouching permanent. Do this by exposing the retouched area to steam. Your tea-kettle can be used as a source of steam. Keep the print about 10 inches (25.4 cm) from the steam source and avoid applying too much steam. Two to three seconds of steam are all that's required.

When the surface marks caused by the application of the dye disappear from the print, you have steamed the print sufficiently.

PENCIL TECHNIQUE FOR SMALL AREAS

Pencil retouching is an alternate to the wet-brush technique for small areas. With a little practice, you'll find that much of the minor retouching that may be necessary can be done quickly and easily with a modest set of soft-lead, colored-retouching pencils. However, it's important to note that there are two slightly different techniques for pencil retouching: one for prints from negatives and one for prints from slides. Both techniques are described here.

RETOUCHING PRINTS FROM NEGATIVES

Materials needed

Soft-lead colored retouching pencils

Spray can of retouching lacquer. (Retouching lacquers are products made specifically for pencil retouching. They contain a matting agent which prepares the surface so it will readily accept pencil retouching.)

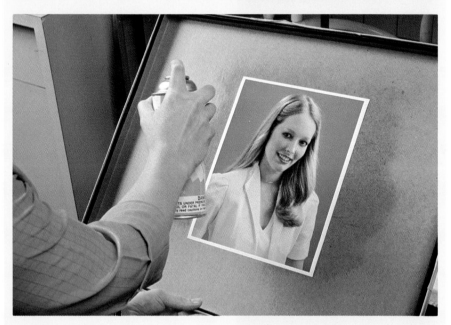

Method

Place the print in an upright position against newspaper or cardboard (to protect countertop, wall, etc from overspray). Spray the entire surface of the print with an even back-and-forth, top-to-bottom motion. Be sure to follow the specific instructions provided by the manufacturer of the particular brand of retouching spray you are using. Allow the surface of the print to dry.

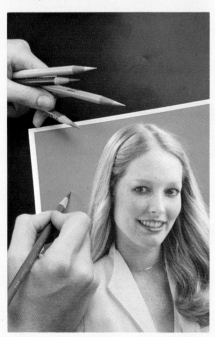

Using a soft, gentle, stroking motion, apply the colored pencil(s) to areas of the print needing spotting or retouching. Vary colors to match the area being retouched.

RETOUCHING PRINTS FROM SLIDES

Materials needed

Soft-lead colored retouching pencils.

Spray can of lacquer designed to provide an overall protective surface for the finished print. (Most brands are available in versions which render a surface in clear, lustre, or matte finish.)

Bottle of white opaque paint.

#4 sable brush.

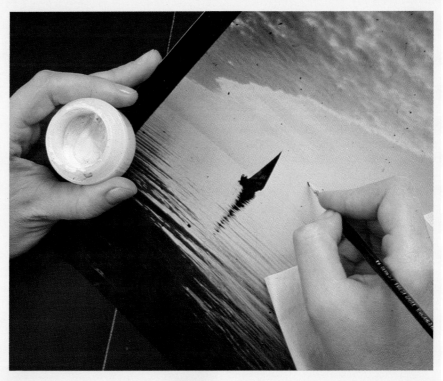

You'll find that most spots are usually due to the presence of dust on the slide during printing. And these dust spots will appear black instead of white. By applying white opaque to these black spots after spraying, you are preparing them for retouching.

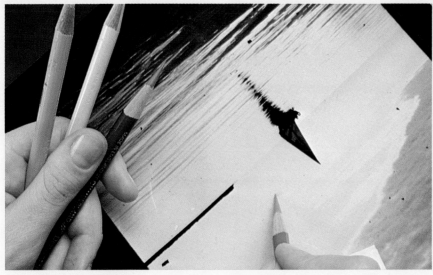

After the white opaque paint has dried, apply the colored pencil(s) to the areas you have painted. Use a soft, gentle, stroking motion in applying the pencil color(s). After you have finished retouching, spray the print to protect the surface and restore an even surface texture.

MOUNTING

There are several advantages to mounting your color prints, the primary one being that a properly mounted print generally looks better than an unmounted print. In addition, mounting makes a print sturdier, and so it should last longer. Finally, mounted prints are more easily framed, and in fact can be handsomely displayed even without frames.

Two methods of mounting prints are detailed in the pages that follow. The second requires specialized materials and equipment, while the first is comparatively inexpensive and requires practically no equipment. With experience, you'll be able to decide which mounting method you prefer.

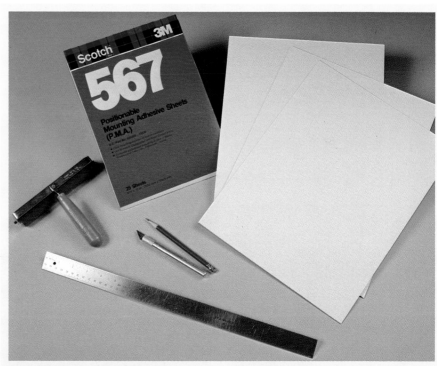

HOW TO MOUNT PRINTS USING COLD MOUNTING SHEETS

This is perhaps the easiest way to mount prints because it requires no special equipment.

MATERIALS NEEDED

Mounting board

Adhesive mounting material (such as *Scotch*™ Brand Positionable Mounting Adhesive Sheets)

Ruler

Pencil

Squeegee or roller

X-ACTO™ knife

Procedure

1. Trim the print to the desired size. You can use the ruler and the X-ACTO knife to get nice, clean, straight edges.

2. Place the adhesive sheet on a flat surface like a counter, printed side down. Then peel the adhesive coated sheet away from the release paper (bottom sheet).

3. Place the print face down on top of the release paper (unprinted side) and gently press the adhesive sheet on to the back of the print. The adhesive sheet can be moved around and repositioned until pressure is applied to it.

4. If there is any excess adhesive sheet around the edges of the print, trim it off.

5. Place the print back on the release paper face down and apply pressure to it with the squeegee or roller. Be sure to press down firmly over the entire back of the print to set the adhesive.

6. Peel the carrier sheet off the back of the print.

7. Place the print down on the mount board face up. It can be moved around until it is where you want it as long as you don't press down on it.

8. Place the release paper over the print, writing side up, and press down firmly with the squeegee or roller to set the adhesive. Be sure to do the entire print so it is all stuck down.

MOUNTING PRINTS USING A TACKING IRON AND MOUNTING PRESS

1. Tack the dry mounting tissue to the center of the back of the print.

MATERIALS NEEDED

Dry mounting press (available from several manufacturers in various sizes). Note: for all steps detailed below, the press should be adjusted for a temperature range of 180 to 210°F (82 to 99°C) and a pressure setting sufficient to bond the print, tissue, and mounting board together in firm contact.

Tacking iron.

Kodak dry mounting tissue, type 2, or the equivalent.

Kraft paper (or some other sturdy, clean, protective paper).

Mounting board.

Scissors, X-ACTO® knife, paper cutter, etc.

2. Trim all excess mounting tissue from around the edge of the print.

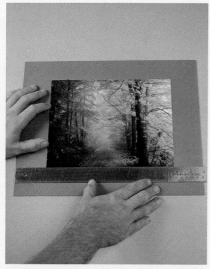

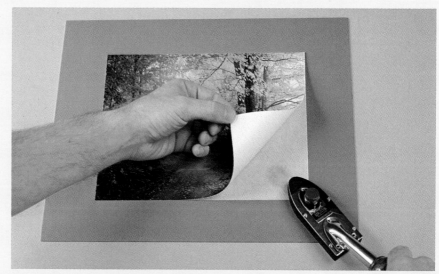

3. Place the print image-side-up on the mounting board and position it squarely in relation to its borders. Then hold the print in place as you lift one corner.

4. With the print lifted, tack the tissue to the mounting board using the flat tip of the tacking iron. Repeat the procedure for each corner.

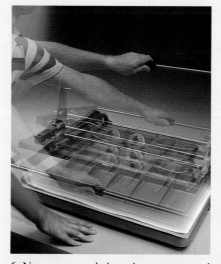

5. Place a cover sheet of clean paper, that has been thoroughly dried by placing it in the hot press for about 20 seconds, over the face of the print. Insert the "sandwich" of mounting board, mounting tissue, print, and cover sheet into the hot press with the covered emulsion side of the print toward the heating platen.

6. Now, open and close the press several times (at approximately 2-second intervals) in order to preheat the "sandwich" and help drive out any residual moisture and/or air. (Trapped air and moisture can cause poor adhesion.)

7. Close the press tightly for 30 seconds as a starting point. Be sure to avoid excess exposure to heat or pressure since this can cause reduced adhesion when the print is first removed from the press.

8. When the appropriate time has elapsed (determined by recommendations related to the type of mounting board and tissue used, size of the print, mounting press, and trial and error) open the press, remove the mounted print, and *immediately* place it face down on a clean, smooth surface (like a counter-top) to cool. A substantial weight (such as a large book) will help keep the mounted print flat until it cools down (about 30 seconds).

MATTING

Think of a mat as a type of "frame" for a photograph. A cardboard mat in a color that complements a photograph, properly proportioned, and expertly cut can add measurably to the impact of that photograph. In addition to its aesthetic appeal, a mat serves a very practical purpose as well: it keeps the surface of the photographic print from touching the glass when a print is framed.

Another advantage is that a matted print doesn't have to be framed at all. It can be displayed effectively and dramatically *without* a frame. Although in most cases for any type of long-term display you should consider the protection afforded by a frame.

Viewing these prints side by side, it's easy to see how much impact is created through the addition of a well-conceived and well-executed mat.

HOW TO CUT A SIMPLE MAT

Materials needed

Mat board

T-Square

Mat cutter

Pencil (soft lead no. 1 or no. 2)

1. Decide on the dimensions of the opening.

2. Mark the *back* of the mat board.

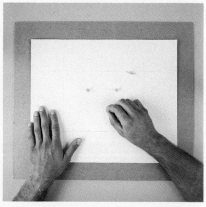

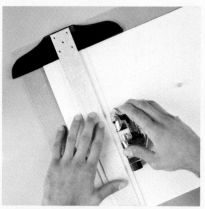

3. Place the board face down on a piece of expendable cardboard. Fasten it down with push pins in the center of the area to be cut out.

4. Start the mat cutter on the line and position the T-square to give you a straight cut. To get square corners, run the mat cutter a bit past each corner.

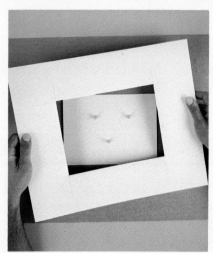

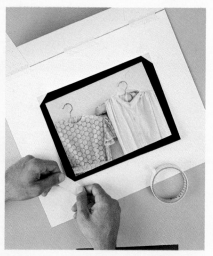

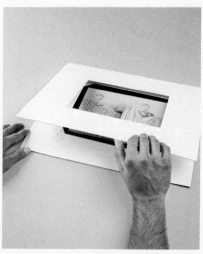

5. When you have cut all 4 sides remove the push pins and pop out the center.

6. Tape the print and mat to a mount board, being careful to position the print properly.

7. Close up the mat and board and you're done.

FRAMING

The final "finishing touch" for any fine photograph is a frame. But when it comes to frames, you have several choices to make. And the reason is because there are so many different types, styles, colors, shapes, and sizes of frames to choose from.

When selecting a frame for a photograph, remember that the photograph is the real focus of attention, not the frame. A frame should enhance and complement the photograph, but never "dominate" it. Your choice of a frame should be based on the following:

How it will relate to the photograph itself (Is the style of the frame consistent with the mood of the photograph? Will the colors clash?).

How it will relate to the room and the decor where it will be displayed.

How it will relate to the other framed items in the same grouping or in the same room.

With so many choices, finding the right framing combination isn't always easy. But making the choice is part of the fun!

Metal frames are popular, contemporary in appearance, sturdy, and easily assembled. You'll find them available in kit form or custom made.

The clip mount frame is nothing more than a piece of glass, a piece of backing material, and clips that hold the whole thing together under tension. The plastic box frame is even easier to put together. Both frames are simple, inexpensive, and strikingly contemporary.

Glossary

Cross-references are <u>underlined</u>

Activator:
alkaline solution that starts silver development in exposed EKTAFLEX PCT film during soak time and promotes dye release and diffusion to paper during lamination.

Agitation:
movement of solutions during processing to ensure that fresh solution is evenly distributed over film or paper.

Aperture:
opening, usually variable in size, through which light enters a lens on a camera or enlarger. Calibrated in <u>f-numbers</u>, its size not only affects exposure, but also sharpness in an image.

Batch (emulsion) Numbers:
numbers identifying specific production runs of light sensitive materials, printed on the package. Important in color printing because different batches of the same material can have slightly different speed and contrast reactions.

Burning-in
see **Printing-in**

CC/CP filters:
yellow (Y), magenta (M), and cyan (C) subtractive printing filters used in sets of various strengths for color correction in color printing.

Color:
how different wavelengths of light appear to us. Can be measured scientifically, but for most photographic purposes, a subjective assessment.

Complementary colors:
the three colors (yellow, magenta, and cyan) that are the exact opposites of the three <u>primaries</u> (blue, green, and red) from which all colors can be obtained. Two colors are complementary to one another if when mixed in the correct proportions they form white light.

Contrast:
subjective judgment of the differences in density and brightness in subject, negative or slide, and print.

Crop:
the editing of an image in the camera or enlarger to leave out parts of the subject/image or alter its shape.

Darkroom:
lighttight room for printing and processing sensitive materials.

Density:
relative opacity in negatives or slides; relative lightness or darkness in prints.

Developer:
chemical solution that brings out latent image on light-sensitive photographic materials — film or paper.

Development:
chemical or physical treatment that converts a latent photographic image into a visible form. Strength of the <u>developer</u>, its temperature, time and degree of agitation affect the process.

Dodging:
witholding light from a local area of the print or film during exposure under the enlarger to control density. The opposite of <u>printing-in</u>.

Enlargement:
increasing the size of the image produced from a negative during printing.

f-numbers, f-stops:
numbers on the lens indicating the size of the <u>aperture</u>. The numerical progression is a proportion of the size of the aperture to the focal length of the lens, so the smaller the f-number, the larger the actual aperture and the more light is admitted.

Ferrotyping:
drying technique that gives prints a high gloss. Should never be used with any <u>resin-coated</u> papers.

Fixer:
solution used after developer to stabilize the image and render it insensitive to light.

Highlights:
the brightest areas on a print or slide.

Latitude:
the margins for error in exposure and development within which image or print quality still seems good.

Lamination:
a process where EKTAFLEX PCT film and paper are pressed together, emulsion-to-emulsion, and dyes are released and transferred from film to paper to produce a finished, positive image.

Local control:
general term for <u>dodging</u> and <u>printing-in</u>.

Matte finish:
a low luster finish printing paper.

Negative:
image produced on the film by exposure in which tones and colors are reversed.

Negative carrier:
holder for the negative or slide positioned between the light source and lens in an enlarger.

Neutral density:
produced when more than two different color filters are used in printing, resulting in long exposure times. Can be eliminated by subtracting lowest filter value from all filters.

Overdevelopment:
either excessive development time, or temperature; usually produces increased density or contrast in the print or negative.

Overexposure:
excessive exposure to light of film or paper.

Printing-in:
method of local shading of film or print under the enlarger so that additional exposure is given to selected areas. Opposite of dodging.

Resin-coated (RC) paper:
printing papers with a water-repellent base for faster processing, washing and drying. All color papers are resin-coated.

Retouching:
local treatment of negative or print with chemicals or dyes to remove blemishes or improve final image. *See* <u>spotting</u>.

Reversal materials;
photographic materials that give a positive image direct, without a intermediate <u>negative</u> being formed.

Ringaround
an array of images showing correct and incorrect color balance. Used to determine the amount of filtration required to correct print color balance to normal.

Safelight:
darkroom illumination that does not affect light-sensitive materials; available in different colors and strengths. Manufacturer's recommendations should be followed for the correct safelight, some color materials can only be handled in total darkness.

Spotting:
<u>retouching</u> unwanted spots in a color print using color dyes or pencils.

Stop bath:
chemical that acts to end development of image by neutralizing developer.

Test strip:
several exposures of different times or filtrations made on one sheet of paper or film during printing to determine the correct exposure for the final print.

Type A color film:
color film balanced to artificial light sources (of color temperature around 3400 K).

Type L color film:
color film balanced to artificial light sources (of color temperature around 3200 K).

Underdevelopment:
reduced development caused by weak solution, shortened development time, or low developer temperature. Produces opposite effects to overdevelopment: lower image density and contrast.

Underexposure:
too little exposure in the camera or enlarger, resulting in reduced density and contrast in the image.

Recommended reading

KODAK Color Darkroom DATAGUIDE (R-19)
$14
Good reference guide for the color darkroom. Gives extensive data about the exposure, processing, and printing of color darkroom materials. The color companion piece for the KODAK Black-and-White Darkroom DATAGUIDE discussed above.
7½ x 8¾ inches, 32 pages.
ISBN 0-87985-086-8

Introduction to Color Photographic Processing (J-3)
$5.75
Gives extensive and current information for advanced amateurs and beginning professionals about processing color films and papers.
8½ x 11 inches, 52 pages.
ISBN 0-87985-216-X

Creative Darkroom Techniques(AG-18)
$9.95
This is an advanced book covering a wide range of darkroom techniques from methods of contrast control to photo silk-screen printing. Many ways to make exciting negatives and slides. Almost 400 illustrations in color and black-and-white.
Hardcover, 6 x 8¾ inches, 292 pages.
ISBN 0-87985-075-2

Basic Chemistry of Photographic Processing (Z-23-ED)
$5.00
Two programmed instruction booklets introduce the photography student to basic concepts in the preparation and use of processing solutions.
8½ x 11 inches,
Part I, 35 pages; Part II, 43 pages.

Photo Decor (O-22)
$8.95
This book tells how to use photography to enhance your surroundings, both at home and at work. Designed primarily as a handbook for professional photographers, interior designers, and decorators, the book will also be of great help to the do-it-yourselfer who simply wants to enjoy beautiful photographs as decoration. Contains more than 250 color and black-and-white photographs offering many new ideas and suggestions.
8½ x 11 inches, 88 pages.
ISBN 0-87985-220-8

Basic Photographic Sensitometry Workbook (Z-22-ED)
$6.50
An introduction to basic photographic sensitometry for photographers, graphic arts camera operators, students, teachers, and all other users of photographic materials.
8½ x 11 inches, 40 pages.
ISBN 0-87985-290-9

Preservation of Photographs (F-30)
$5.50
Repairing deterioration that has already taken place and improving storage conditions of photographic collections are just two of the topics discussed in this book. Although written primarily for those who have charge of storing negatives and prints, it will also be helpful for those who are concerned with processing.
8½ x 11 inches, 60 pages.
ISBN 0-87985-212-7

Prices shown are suggested prices only and are subject to change without notice. Actual selling prices are determined by the dealer.

*Photographed on KODACHROME Film, this
scene shows the sort of bright, saturated
colors that make exciting prints.*

Index

POISON INFORMATION FOR KODAK PRODUCTS
Emergency information is available on a 24-hour basis. The telephone number is:

(716) 722-0271

If questions arise about hazards of photochemicals:

Read The Label: The precautionary and first-aid statements presented on the label are carefully thought out and will answer many of the questions raised about photochemical hazards. If additional information is needed concerning physical effects resulting from contact with Kodak chemicals, write to:
Eastman Kodak Company
Health and Safety Laboratory
Kodak Park
Rochester, New York 14650.

HELP US BUILD BETTER BOOKS!

(And *help yourself* to a free subscription to KODAK Photonews . . . the newsletter that gives you current information about Kodak products along with tips on how to take better pictures.)

Instructions: Please take a few moments to answer the questions on this reader survey card. We value your assistance, and we'll use the information to help us produce publications which will be meaningful and useful to you. As a way of saying thanks for completing this survey, we'll send you a free subscription to a fascinating newsletter: KODAK *Photonews.* All responses will, of course, be kept confidential.
Thank you!

(1) **6**
(2-7) _____

1. Which of the following categories describes your involvement in photography? (Check all applicable.)

(8) ☐ *Rarely* take pictures.
(9) ☐ *Only* take pictures of "special events" such as birthdays, vacation trips, holidays, celebrations, etc.
(10) ☐ *Frequently* take pictures of family, friends, and normal activities as well as birthdays, vacation trips, holiday celebrations, etc.
(11) ☐ *Very* interested in photography and consider it to be my hobby.
(12) ☐ *Student* in photography.
(13) ☐ *Teacher* of photography.
(14) ☐ *Not a professional* photographer or technician, but use some photography in my job.
(15) ☐ *Part-time professional* photographer or technician.
(16) ☐ *Full-time professional* photographer or technician.

2. What *percentage* of your personal annual income is derived from photography? (Check one.)

(17) ☐ 100%
☐ 50-99%
☐ 25-49%
☐ 1-24%
☐ None

3. Please estimate the amount of film you personally use (not work related) during an average year.

(18-20) 35 mm:_____rolls
(21-23) 120 roll:_____rolls
(24-26) Sheet:_____boxes

4. Approximately how much did you spend during the past year on your *personal* photographic activities (including film, darkroom materials, reference literature, etc.)?

Estimated dollars spent on photography during past year.

(27-31) $_____

5. How many books on photography do you presently have in your *personal* photographic library? (Check one.)

(32) ☐ 3 or less
☐ 4 to 15
☐ More than 15

6. How did you *first* learn about this book? (Check one.)

(33) ☐ A Kodak ad
☐ A magazine or newspaper article
☐ A book review
☐ A salesperson
☐ A friend
☐ Saw it in the store
☐ A teacher
☐ Other

7. How did you obtain this book? (Check one.)

(34) ☐ Bought it in a camera store
☐ Bought it in a book store
☐ Bought it in a discount store
☐ Received it as a gift
☐ Other

8. In what situations will you be using this book most frequently? (Check all applicable.)

(35) ☐ For personal use (hobby)
(36) ☐ At school or during instruction
(37) ☐ On the job (work related)

9. Please indicate your level of satisfaction with this *Kodak Workshop Series* book relative to the characteristics listed. Use a rating scale of 1 to 5. (1 = Very Satisfied, 5 = Very Dissatisfied) Please check appropriate box (#1 through 5) for *each* characteristic listed.

Characteristics of This Book	Very Satisfied 1	2	3	4	Very Dissatisfied 5
(38) "How-To" Workshop Format	☐	☐	☐	☐	☐
(39) Organization of Information	☐	☐	☐	☐	☐
(40) Style of Writing	☐	☐	☐	☐	☐
(41) Photographs	☐	☐	☐	☐	☐
(42) Drawings, Diagrams, and Illustrations	☐	☐	☐	☐	☐
(43) Quality of the Printing	☐	☐	☐	☐	☐

10. Of the following books available in the current *Kodak Workshop Series,* which do you now own or plan to buy? (Check all applicable.)

(44) ☐ *Black-and-White Darkroom Techniques*
(45) ☐ *Photography with Automatic Cameras*
(46) ☐ *Electronic Flash*
(47) ☐ *Using Filters*
(48) ☐ *Building A Home Darkroom*
(49) ☐ *Color Printing Techniques*

11. Of the following *proposed future titles* for the *Kodak Workshop Series,* please indicate the titles that you would be *interested* in owning.

(50) ☐ Close-Up Photography
(51) ☐ Advanced Darkroom Techniques
(52) ☐ Existing-Light Photography
(53) ☐ Nature Photography
(54) ☐ Lenses and Lens Attachments
(55) ☐ Photojournalism
(56) ☐ Antique Photographic Techniques
(57) ☐ The "Art of Seeing" With Your Camera
(58) ☐ Black-and-White Photography
(59) ☐ Basic Lighting Techniques
(60) ☐ Photography for Special Effects
(61) ☐ Setting Up a Home Studio
(62) ☐ Photographing Children
(63) ☐ Portrait Photography
(64) ☐ Travel Photography
(65) ☐ Sports Photography
(66) ☐ Photography With a Video Camera
(67) ☐ Matting, Mounting, and Framing
(68) ☐ Decorating With Photography
(69) ☐ Landscapes and Scenics
(70) ☐ Establishing Your Personal Style
(71) ☐ Backpacking and Photography
(72) ☐ Underwater Photography
(73) ☐ Photography Under Adverse Conditions

Continued on reverse side

12. Which of the following identifies your age group?

(74) ☐ Under 18
☐ 18-24
☐ 25-34
☐ 35-44
☐ 45-54
☐ 55 and Over

13. Which of the following identifies your education? (Check one.)

(75) ☐ High school
☐ Now attending college
☐ Some college
☐ Graduated from college
☐ Graduate level courses or degree

14. Which of the following identifies your gross annual income? (Check one.)

(76) ☐ Under $10,000
☐ $10,000 to $19,999
☐ $20,000 to $29,999
☐ Over $30,000

(77-105) Your Name:_____
(106-135) Address:_____
(136-165) _____
(166-185) City:_____
(186-195) State or Province:_____
(196-201) Zip:_____
(202-211) Country:_____

Thank you for your time and your thoughts. Learning about your photographic interests and needs is an important part of our planning of new publications in the *Kodak Workshop Series.* Your name will be entered for a free subscription to *KODAK Photonews* which is sent out about twice a year.

To mail this survey: Simply fold as indicated. Then tape closed and mail. No postage is required.

- -

(FOLD HERE—TAPE CLOSED)

KODAK WORKSHOP SERIES
CONFIDENTIAL
READER SURVEY

- -

(FOLD HERE—TAPE CLOSED)

NO POSTAGE
NECESSARY
IF MAILED
IN THE
UNITED STATES

BUSINESS REPLY MAIL
FIRST CLASS PERMIT NO. 131 ROCHESTER, N.Y.

POSTAGE WILL BE PAID BY ADDRESSEE

Eastman Kodak Company
Robert E. White, Jr.
C/PFM
343 State Street
Rochester, New York 14651